DESERT JEWELS

NORTH AFRICAN JEWELRY AND
PHOTOGRAPHY FROM THE
XAVIER GUERRAND-HERMÈS
COLLECTION

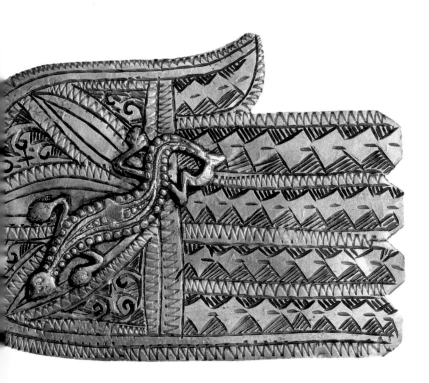

DESERT JEWELS

NORTH AFRICAN JEWELRY AND
PHOTOGRAPHY FROM THE
XAVIER GUERRAND-HERMÈS
COLLECTION

ESSAYS BY
KRISTYNE LOUGHRAN
CYNTHIA BECKER

MUSEUM FOR AFRICAN ART
NEW YORK

MUSEUM
FOR
AFRICAN
ART

Desert Jewels: North African Jewelry and Photography from the Xavier Guerrand-Hermès Collection is published in conjunction with an exhibition of the same title organized by the Museum for African Art, New York. The exhibition will have a national tour, made possible through the generous support of Merrill Lynch, before opening in New York at the Museum for African Art.

Merrill Lynch

Chief Curator and Director of Exhibitions
and Publications: Enid Schildkrout
Publication Coordinators: Carol Braide and Donna Ghelerter
Design: Florio Design
Photography: Karin L. Willis

Library of Congress Control Number: 2008938801
Paper bound ISBN 978-0-945802-52-5

Distributed by:
University of Washington Press
P.O. Box 50096
Seattle, WA 98145-5096
www.washington.edu/uwpress

Front cover: *Necklace* (detail), late 20th century
(some 19th-century elements), Aït Atta people, Jebel Sarhro, Morocco

Back cover: *Palms at Giza*, Pascal Sebah, ca. 1870, Egypt,
8 x 10½ in., albumen print from a collodion glass negative

Printed and bound by J. S. McCarthy Printers, Augusta, ME

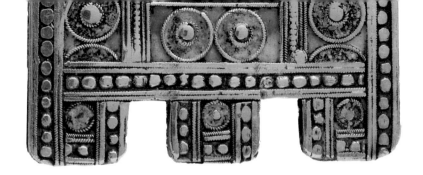

6 SPONSOR'S LETTER

7 FOREWORD

· ·

8 **JEWELS IN THE DUST**
 KRISTYNE LOUGHRAN

19 **GLOSSARY: METALWORK TECHNIQUES**

68 **PHOTOGRAPHIC ENCOUNTERS ON THE NORTH AFRICAN STAGE**
 CYNTHIA BECKER

· ·

94 CONTRIBUTORS AND COLLECTION NOTES

95 MUSEUM FOR AFRICAN ART BOARD AND STAFF

SPONSOR'S LETTER

Merrill Lynch is proud to be national tour sponsor of *Desert Jewels: North African Jewelry and Photography from the Xavier Guerrand-Hermès Collection*, an exhibition of spectacular jewelry and historic photographs from the North African nations of Algeria, Libya, Morocco, Egypt, and Tunisia.

Collected over three decades by Xavier Guerrand-Hermès, *Desert Jewels* illuminates the diversity and beauty of traditional North African jewelry design and pairs these exquisite pieces with images by prominent late nineteenth- and early twentieth-century photographers of people adorned in the jewels. Ornate necklaces, bracelets, rings, and earrings crafted from combinations of silver, coral, amber, coins, and semi-precious stones reveal the inventive compositions and dazzling creations of North African jewelry designers and silver workers. The jewelry featured in *Desert Jewels* shows the diversity of North African culture and also local variations in materials and techniques.

We recognize the importance of investing in the preservation and development of cultural and educational programming around the world. Over the years, we have partnered with leading organizations globally to provide greater public access to cultural programming for diverse audiences and to the communities where our clients and employees work and live.

Desert Jewels is a treasure that reflects the richness of the cultures of North Africa. Our deepest appreciation to Xavier Guerrand-Hermès and the Museum for African Art for bringing this extraordinary collection to us all.

FOREWORD

It is a great honor for the Museum for African Art to present to the public a small portion of Mr. Xavier Guerrand-Hermès' magnificent collection of North African jewelry and photography. The Hermès name is, of course, synonymous with style and impeccable taste, whether in jewelry, textiles, leatherwork, or clothing. It is no surprise, then, that this collection of fine jewelry from Morocco, Algeria, and Tunisia, amassed over decades by Mr. Guerrand-Hermès himself, is evidence of the keen eye of one member of this great fashion family. Living in Morocco, Mr. Guerrand-Hermès developed a deep appreciation for the peoples and cultures of the region. He was especially cognizant of the rich history, the mosaic of peoples, and the high level of artistic production. Inspired by the creative mix of materials found in the necklaces, bracelets, fibulae, and pendants of North Africa, Mr. Guerrand-Hermès has built a collection that shows not only his connoisseurship but also the range of styles that have been made throughout the region over time.

The Guerrand-Hermès photography collection beautifully complements the jewelry and also provides an amazing window into North African life at the turn of the twentieth century. Featuring work by some of the most important figures in late nineteenth- and early twentieth-century photography, the images show the enduring Western fascination with North Africa and reveal the mixture of peoples—Arabs, Jews, sub-Saharan Africans, and Imazighen—who created the great cultures of the region.

The Museum for African Art is proud to be the recipient of a generous gift of jewelry from Mr. Guerrand-Hermès and is honored to tour part of his collection to the public. We owe special thanks to Mr. Guerrand-Hermès, as well as to his curator, Gabriel Ringhilescu, who worked tirelessly with our registrar, Kate Caiazza, to make the exhibition possible. Thanks also go to Enid Schildkrout and Jerry Vogel, as well as to Carol Braide, Linda Florio, Donna Ghelerter, Karl Knauer, Alec Madoff, Sarah Nunberg, Brendan Wattenberg, and Karin Willis, all of whom worked on the project over many months, and to Kristyne Loughran and Cynthia Becker, whose informative essays we are proud to present in this book.

We are also most grateful to Merrill Lynch for wholeheartedly supporting the Museum for African Art and, particularly, this wonderful book and exhibition.

Elsie McCabe Thompson
President, Museum for African Art
November 2008

JEWELS IN THE DUST

Kristyne Loughran

Enameled bracelet,
In the Aydel mountains
You are a prisoner
Of snow and the winds.

Light silver bracelet
Lost at the fountain,
Tell me of the beloved one,
What became of him?

Coral bracelet
During the time of olives,
Go tell the young man
That I have been neglected.

IN NORTH AFRICAN love poetry and songs, jewelry symbolizes the important stages of women's lives. The poem opening this essay, collected by singer Taous Amrouche in the Great Kabylie, Algeria, alludes to courtship during the olive-picking season and uses bracelets, such as the striking *amesluh* (cat. 40), as a metaphor for love, marriage, and continuity.[1] Such bracelets are one of the many striking styles of North African jewelry. Ornate, colorful, and heavy, these bold jewels, often assembled from different textures and materials, express the cultural diversity of North Africa and the mingling of its many peoples. At the same time, their singular and recognizable imprint, reflecting processes of cultural adaptation and fusion over centuries, has made these ornaments a contemporary symbol of the identity of the Amazigh people, also known as Berber, who live in many countries in the region.[2]

 Most of the jewelry in the Xavier Guerrand-Hermès collection is Amazigh or in the Amazigh style, and the majority of the pieces are from Morocco. The Imazighen are semi-nomadic pastoralists and sedentary farmers from the mountainous and desert regions of Morocco, Algeria, Tunisia, Libya, and Egypt.

Jewelry plays an important role in their lives. Amazigh women receive jewelry as part of the bridal wealth from their future husbands; these pieces confer social status, represent financial stability, and are emblematic of their group affiliation. The most remarkable features of Amazigh jewelry are the breadth of styles and the skilled artistry evident in these stunning works that North African women wear in copious amounts.

Elegant jewelry traditions developed in important Moroccan urban centers like Meknès and the imperial city of Fez.[3] These ornaments, fashioned in gold and semi-precious stones, display intricate handwork and an eye for harmony. The delicate enameled belt buckles from Morocco (cat. 28) and the lovely silver hats (cat. 1), worn by Moorish and Jewish ladies, reflect urban tastes. Jewelry from rural areas such as the Western Anti-Atlas and the Middle Atlas and the Draa Valley in Morocco is flamboyant and often enhanced by vibrant and colorful enamel work. Women endlessly layer headbands, head ornaments, plaques and pendants, giving their adornment an aura of opulence (cat. 29). However, rural and urban jewelry traditions have inspired and shaped each other for centuries resulting in a fusion of styles and techniques. Jewelry pieces are relatively small, and it is not uncommon to see items from one country or region worn in another. The cosmopolitan approach to creativity in the many styles of North African adornment results from contact and artistic exchange among the early Mediterranean civilizations of the Carthaginians, the Greeks, Romans, the Arabs, the Ottoman Turks, and the Moors from Spain.

HISTORICAL PERSPECTIVES

The vast area commonly referred to as the *Maghreb*,[4] the Arabic word for "the West," has been a crossroads between the Middle East, sub-Saharan Africa, and Europe for millennia. Contact and trade with the Amazigh peoples, who are considered to be the original inhabitants of North Africa, began in 814 BCE when the Phoenicians founded Carthage. This contact was followed by relations with the Roman Empire and by the presence of Greek settlements in Cyrenaica (Eastern Libya) in the sixth century BCE. These early associations brought new agricultural skills and innovations in weaving, ceramics, and metalworking.

The clear stylistic roots of Amazigh jewelry in early Mediterranean culture and aesthetic systems can be seen in techniques and other influences. Archaeological findings in Greek and Roman settlements have yielded gold and silver jewelry pieces.[5] Technology introduced by Greeks included granulation, piercing, and filigree, as well as engraving and repoussé work. The Romans brought opus interrasile and the niello techniques. Later still, cloisonné enameling, which was

also known to the Ancient Egyptians, traveled to the region by way of Vandal and Byzantine influences (between 429 to 647 CE).[6] The Ottoman period is distinguished by the richness of the jewelry pieces and the introduction and popularity of crowns and diadems.[7]

The Arab conquest at the end of the seventh century CE left a profound and lasting mark on North African culture and the arts. Following the Arab invasions, the Amazigh peoples converted to Islam and were assimilated into Arab communities, although always preserving their cultural identity. The Imazighen are divided into different confederations or groups who speak distinct languages in addition to Arabic. They played an important role in the Moorish conquest of Spain in the eighth century, and the Almoravid and Almohad Dynasties built empires in North Africa and Spain between 1091 and 1237.[8]

Some accounts from early travelers to the region make mention of North African jewelry. For example, in *Description de L'Afrique*, published in 1550, Jean-Leon l'Africain indicates that women in Fez are given silver jewelry as part of the bridal dowry.[9] Frederick Horneman's journal, written in the years 1797–8, contains a detailed account of the earrings, bracelets, anklets, and headdresses worn by women from different social classes in Libya.[10] Political events such as Napoleon Bonaparte's Egyptian campaign in 1798–9, the French takeover of Algiers in 1830, and the implementation of the French Protectorates in Tunisia in 1881 and in Morocco in 1912, all contributed to the increased public interest in the Maghreb. These events also fueled the creative imagination, stimulating the demand in the arts for Orientalist themes of harems, hunting, and war, as well as exotic landscapes and cityscapes.[11]

Many painters actually traveled to Algeria, Morocco, and Egypt, and some, such as Alphonse-Étienne Dinet (1861–1929), settled there. Others remained at home, turning to literature and travelers' accounts for inspiration. Clothing, carpets, and other props gave their works an Orientalist imprint. It was difficult, if not impossible, for painters to enter the female arena in the Maghreb, and many artists resorted to sketching, then to photographs as "aide-memoirs."[12] *Women of Algiers in Their Apartment* (1834) by Eugène Delacroix, *Moorish Bath* (1870) by Jean-Léon Gérôme, and *The Great Odalisque* (1814) by Jean-Auguste-Dominique Ingres all show women in various poses in interior scenes.[13]

Some painters depicted women's jewelry in great detail. The Spaniard José Tapiró y Baró (1836–1916), who settled in Tangier in 1876, is known for lavish interior scenes and detailed images of women's jewelry. In his *Preparation for the Wedding of the Daughter of the Cherif of Tangiers*,[14] a young woman wearing earrings, bracelets, and anklets sits on a bed, surrounded by servants preparing

ATLANTIC OCEAN

ALGIERS ⊙ Constantine ● TUNIS ⊙
GREAT KABYLIE
SMALL KABYLIE Moknine ●

Tangier ● ● Tetouan
Ouezzane ● ● *Er Rif* TELL ATLAS TUNISIA Sfax ●
RABAT ⊙ Meknes ● Isle of
Casablanca ● ● Fez Taza ● Jerba

MOROCCO Khenifra ● SAHARAN ATLAS
 MIDDLE ATLAS
 Medenine ●
Essaouira ● Marrakech ● HIGH ATLAS Tataouine ●
 Jebel Sarhro *Draa Valley* PRE-SAHARA
Irherm ● △ *Jebel*
Tafraoute ● ANTI-ATLAS *Siroua* ALGERIA
Tiznit ● *Jebel Bani*
Foum El Hassane ●

for her wedding ceremony. The servants are also bedecked with earrings,
anklets, and bracelets. In the artist's luminous portrait, *Moorish Woman*[15] (early
twentieth century), a young woman dressed in a richly embroidered caftan wears
a pearl diadem, gold and coral earrings, necklaces of pearls, stones, and gold;
she regards the viewer with a quiet, peaceful gaze. Another well-known example,
Emile Vernet-Lecomte's *Berber Woman* (1870), presents the subject adorned
with a diadem and bracelet in the Kabyle style.[16] Many international artists in
the nineteenth century, including the American painter John Singer Sargent
(1856–1925), the British painter John Frederick Lewis (1805–1876), the Italian
painter Giuseppe Signorini (1857–1932), and the Spanish painter Mariano
Fortuny Marsal (1838–1874) also produced works with Orientalist themes.

In addition to the lavish jewelry and adornment, Orientalist paintings display
other North African arts such as delicate pottery and ceramics, exquisitely
embroidered and woven textiles and carpets, elegant woodwork, leatherwork,
and metalwork. These items illustrate the rich aesthetic expressions present in
Islamic and Amazigh art that captured the attention of many travelers, artists,
photographers, and scholars.[17]

THE MAGHREB STYLE

The aesthetic of North African jewelry is fundamentally rooted in the idea of abundance and all it encompasses: large sizes, the appeal of lavish designs, movement and noise, sensuality, sweet smells, and flamboyance. Rural pieces espouse symmetrical, clean, and repetitive geometric shapes and surface decorations. Urban pieces display floral, arabesque, and rounded designs issuing from the Arab, Andalusian, and Moor traditions. This blending has resulted in the Maghreb style, which is a tribute to the technical expertise and aesthetic judgment of its makers. Traditional motifs used in Amazigh art are repeated from one generation to the next, but their nomenclature often changes over time.[18]

Design and technology are often inseparable, and jewelry pieces from different Amazigh groups sometimes display many similarities. This is because the materials, tools, and techniques used to produce jewelry influence the designs of the objects.[19] Since jewelry items travel easily, it is not unusual for various groups to utilize the same styles. Composition and surface ornamentation are the determining factors that shape these artistic expressions. As art historian Ivo Grammet notes, "Objects of daily life show an aesthetic consciousness, which is based on a technique and on a language of forms. Ethnic identity determines the aesthetic codes and rules."[20]

Color reinforces the balance and overall symmetry of the pieces. The red, green, yellow, and blue enamels and the niello designs create harmonious contrasts, as does the interplay between metals and colored stones. This is evident in Zaïane *beurmil* pendants and the niello designs on silver pendants favored by the Aït Serhrouchen. The *chems ou qmar* or *lune et soleil* (moon and sun) bracelets, as their name indicates, illustrate this in a compelling manner: the dark sections allude to night or darkness whereas the gold-leaf sections suggest day and light (cat. 42).[21]

AMAZIGH JEWELRY FORMS

The elaborate necklaces, fibulae, bracelets, head ornaments, and belt buckles, worn by Amazigh women as an integral part of their apparel, emphasize and visually link different parts of the body. The many items of jewelry a woman wears do not necessarily consist of matching pieces. Often the placement of the jewels has symbolic meaning. For example, diadems worn at weddings emphasize and heighten the forehead thus empowering the bride with the solemnity necessary during the appearance ritual (*bezra*).[22] *Lebba* necklaces (cat. 12) call attention to a woman's chest and enhance her figure because of the graduated pendants. The noises the ornaments make when women walk announce their

presence and chase away evil spirits. Beautifully engraved fibulae are essential ornaments that fasten capes and shawls and secure the bride's veil at her shoulders during the wedding ceremony.[23] Jewelry complements clothing and symbolizes well-being. On a more intimate level, women use jewelry to enhance their physical attributes and femininity, their movements, and to confirm their roles as the keepers of tradition. Women wear jewelry on a daily basis and don their most prestigious head ornaments, large necklaces, and fibulae for important events such as community festivals or weddings. Jewelry is such a significant element of the wedding ceremony that only wealthy families can afford to purchase all the necessary pieces. When required, individuals turn to the *neggafas* (a corporation of women who specialize in the marriage tradition) and rent the appropriate adornment and clothing.[24]

The role of jewelry extends to other family members as well. Women make small necklaces for their children. Jewelry and beads for necklaces are given by mothers to their daughters until they marry. A bride receives jewelry, including bracelets and earrings, from her groom. These are valuable commodities that can be sold in times of need. For boys, necklaces are decorated with little swords and other amulets to protect them from harm; these pieces are much more intricate than those made for girls. Today, men usually wear only a ring or an amulet but in earlier times a man would wear a dagger at the waist.

MOTIVATED SYMBOLS

Jewelry shapes, decorative motifs, colors, and materials carry inherent symbolic meanings. The need to seek protection against evil, jealousy, and misfortune, and to attract goodness (*baraka*) exists throughout the Mediterranean world. Jewelry made in certain shapes (the triangle), materials (silver, amber, and coral), and motifs (hands or birds) serve as protections against evil, jealousy, and evil spirits (*djouns*).

The hand is the most prevalent amuletic shape in North Africa. Referred to as the *hand of Fatima* or *khamsa* (meaning the number five in Arabic), hand amulets often include coded inscriptions in Arabic and Hebrew (cats. 19–20). Other amulets take their shapes from the animal and plant worlds. Snakes and salamanders (cat. 21), birds and rams have prophylactic qualities. Plants, such as palm trees, symbolize the source of life, and pears (the shape of *beurmil* pendants) invoke fertility. Stars (cat. 22), moons, and crosses also provide protection. Direct references to the natural world are often disguised by highly abstract designs; motifs, such as spirals which symbolize eternity (cat. 15), and zigzag lines, which often refer to animals such as the snake, are thought to give protection.

In the Amazigh design nomenclature, human representations are extremely stylized. Triangular shapes have several connotations: they recall images of the Carthaginian goddess Tanit and represent an eye motif that offers protection against the evil eye. Hands of Fatima are the most direct allusion to the human body in Maghreb jewelry forms.

MATERIALS AND TECHNIQUES

Scholars generally agree that many jewelers in the Maghreb were Islamized itinerant Imazighen or Jewish artists who had emigrated from the Middle East at an early date. Those who settled in the Anti-Atlas in Morocco in the sixteenth century emigrated from Spain fleeing the Reconquista. These jewelers brought Hispanic and Moorish styles and technology with them, in particular niello, filigree, enameling, and the art of bezel settings—all traditions that evolved from Byzantine and Visigoth practices.[25] In the Great Kabylie region of Algeria, jewelers were Islamized Jews from the Small Kabylie.[26] In urban centers, jewelers were organized in guilds and worked under the supervision of a master smith, while in rural areas, small workshops produced items for both Amazigh and Jewish clienteles. With the exception of headdresses worn by Jewish women and objects used for religious purposes, Amazigh and Jewish jewelry designs are very similar.[27] As with other groups in Africa, young boys apprentice themselves to male relatives, learning to make jewelry through a long process of observation and practice.

Traditional materials used to manufacture North African jewelry include the precious metals and stones associated with jewelry in the West, such as rubies, emeralds, pearls, and diamonds, along with organic materials. The precious and semi-precious stones imported from Europe and the Middle East are combined with fibers, shells, and seeds, as well as skin, bone, ivory, and horn found in Africa. At an early time, emeralds and beryls were mined near Fez. Coral was, and still is, considered a precious stone and thought to have medicinal properties; it was extracted off the Algerian coast until 1860, when Italian fishermen took over the market.[28] Baroque pearls were popular in urban jewelry because of their irregular shape, and some scholars have suggested that this fashion originated in Granada, Spain.[29] Amazonite (microcline feldspar) often replaces emeralds in the southern regions and carnelian and Venetian mille fiori beads are esteemed as well.

Beads of coral, amber, copal, and glass are used to make necklaces and earrings. The large amber and copal beads that distinguish many necklaces (cat. 7) are highly valued, symbolizing wealth and attributed with protective

and medicinal properties. Today, amber beads are often replaced with copal resin beads or with round yellow beads made of goat horn. Shells, such as cowries and Conus whorls, are often used in hair ornaments (cat. 2).

The luster of much North African jewelry derives from the metals from which it is crafted including gold, silver, copper, nickel, and tin, and alloys such as brass and bronze. Gold, traditionally reserved for urban jewelry, was acquired through trade from sub-Saharan Africa. Morocco had silver mines of its own, and some early Moroccan pieces bear seals from urban centers such as Meknès, Marrakech, or Essaouira.[30] Silver was also obtained from foreign coins, such as the Alphonso XII Spanish *douros* and *pesetas*, the French *Napoleons* or what were known as the *Hassani douros* (coins minted in France for Sultan Moulay Hassan), and Maria Theresa *thalers*.[31]

Silver is a preferred metal of Amazigh groups and is appreciated for its luminosity and color. It is thought to bestow the wearer with divine light and blessings and to symbolize purity. Rural jewelry is traditionally made of silver while urban pieces are made of silver, gold, and gilt silver. Gold was always the preferred metal in urban centers, where it was more easily available.[32] Some pieces, such as the "sun and moon" bracelets (cat. 42) incorporate both.

Jewelers work with forms that are either made of one piece of metal (cat. 43) or composites of different elements. Some pieces require only casting and decoration, whereas others necessitate more elaborate processing of the metals—such as bending, doming, soldering, repoussé, chasing, and metal inlay—before the decorative applications may begin. Jewelry often incorporates multiple techniques, including filigree, enamel, niello, piercing, embossing, and engraving, among others, to create the distinctive Amazigh patterns.

Filigree sometimes appears as a decorative element in fibulae, bracelets, and rings. In Morocco, filigree work was common in Tiznit, Essaouira, and the Anti-Atlas regions. Jewelers in the Anti-Atlas region perfected a technique to manufacture fibulae known as *tizerzaï n'taouka*, or *les fibules du ver* in French, where the effect of filigree is achieved by another method (cat. 32). In this instance, very small silver cylinders are soldered onto the surface of a silver piece, thereby creating a startling visual effect: the heavy silver piece appears to be lightweight due to the openness of the applied circles.[33]

Enameled designs and decorations are notable elements of North African jewelry. At the end of the nineteenth and beginning of the twentieth centuries, enamel work was practiced in Great Kabylie, Algeria by the Aït Yenni people, in Moknine and Jerba in Tunisia, and in the Anti-Atlas region in Morocco. The city of Tiznit was especially known for its yellow and green enamels (cat. 41).[34] Blue,

green, yellow, and some red (often wax) are the favored colors, and the qualities of the enamels vary. Cloisonné enamels are opaque with older examples displaying color variations because they were made with natural substances. Champlevé enamels, preferred by the Zaïane group near Meknès in shades of blue or dark green, are often used to make bracelets.

The niello technique, a prominent feature of North African silver jewelry, consists of pouring black enamel into cutout designs. In some regions, and more commonly in recent times, jewelers use resin from the prickly juniper bush (*Juniperus oxycedrus*) to create niello-style decorations. The resin darkens and hardens when exposed to light, creating a pleasing color contrast with the silver. The Aït Serrhouchen people from the Middle Atlas region and the Ida Ou Nadif in the Western Anti-Atlas region wear head ornaments and necklaces (cat. 14) with very refined niello designs.

The distinctive pieces in the Xavier Guerrand-Hermès collection, many dating from the early part of the twentieth century, represent the rich variety and breadth of North African jewelry designs. These historic works illustrate the adaptation and evolution of jewelry forms and styles over time, as well as the cosmopolitanism of jewelers and their patrons. Today, even as smaller and lighter chains from India, Indonesia, and the Middle East compete with North African jewelry markets, and synthetic materials often substitute for coral and amber, some traditional objects, such as diadems, continue to be manufactured for weddings.[35] Amazigh jewelry is truly invested with cultural meaning, and expressions of self-adornment continue to proclaim the prolific and diverse heritage of North Africa.

NOTES

1 For the French text of the poem, see Wassyla Tamzali, *Abzim: Parures et Bijoux des Femmes d'Algérie* (Paris: Dessain et Tolra, 1984), 168. The translation from the French is mine.

2 Because of the negative connotations of the word Berber (from the Latin *barbarus* or barbarian), Berbers call themselves *Imazighen*. *Amazigh* is the singular and adjectival form. The *Imazighen* consider themselves the indigenous inhabitants of North Africa, and refer to themselves by their group names. The word *Aït* means "people of."

3 Abderrahman Slaoui, *Parures en Or du Maroc: Trésors des Cités Impériales* (Barcelona: Malika Editions, 1999), 21.

4 The North African nations of Algeria, Tunisia, Morocco, and Libya are often referred to as the Maghreb.

5 In 1925, when French archaeologists discovered the tomb of Queen Tin Hinan, the mythical ancestress of the Tuareg, they found the figure of a woman surrounded with gold and silver bracelets and beads.

6 Tatiana Benfoughal, *Bijoux & Parures d'Algérie: Histoire, Techniques, Symboles* (Paris: Somogy Editions d'Art, 2003), 25.

7 Ibid., 36.

8 Ivo Grammet, "Les Bijoux" in *Splendeurs du Maroc* (Tervuren: Musée Royal de l'Afrique Centrale, 1998), 216.

9 See Jean-Leon l'Africain, *Description de l'Afrique*, trans. from Italian by A. Epaulard, 1956 (reprint. Paris: J. Maisonneuve, 1981), vol. 1, 208.

10 See Frederick, Horneman, *The Journal of Frederick Horneman's Travels, from Cairo to Mourzourk, the Capital of the Kingdom of the Fezzan, in Africa in the Years 1797–8*, 1802 (reprint. London: Darf Publishers Limited, 1985), 70–71.

11 See Lynne Thornton, *The Orientalists: Painters-Travellers* (Paris: ACR Edition, 1994), 4.

12 See Thornton, *The Orientalists*, 10.

13 *Women of Algiers in Their Apartment* (1834, Musée du Louvre, Paris) by Eugène Delacroix, *Moorish Bath* (1870, Museum of Fine Arts, Boston) by Jean-Léon Gérôme, and *The Great Odalisque* (1814, Musée du Louvre, Paris) by Jean-Auguste-Dominique Ingres.

14 Watercolor and gouache on board, 71 x 49.5 cm., private collection, Rome, Italy.

15 Watercolor on paper, 69 x 57.5 cm., National Art Museum of Catalonia Collection, Barcelona. For the illustration, see Ramirez and Rolot, 25.

16 Oil on canvas, 122 x 87 cm., private collection. For the illustration, see Ramirez and Rolot, 325.

17 Research on the subject of North African jewelry by European scholars, primarily French, began in the 1900s. The work of writer and critic Paul Eudel, *L'Orfèvrerie Algérienne et Tunisienne*, published in 1902, includes detailed illustrations of jewelry forms. Jean Besancenot, a French ethnologist whose specialty was Morocco, published *Costumes du Maroc* in 1942, which depicts the rich diversity of Moroccan dress and adornment.

18 During my fieldwork in Niger among Tuareg jewelers, many of the younger generations recognized stamp motifs used by their elders but no longer knew their names. In some instances, they gave them new names. For similar observations, see also Cynthia J. Becker, *Amazigh Arts in Morocco: Women Shaping Berber Identity* (Austin: University of Texas Press, 2006), 28.

19 Oppi Untracht, "Materials and Techniques" in *Ethnic Jewelry*, ed. John Mack (New York: Harry N. Abrams, 1988), 173.

20 Grammet, "Les Bijoux," 84. The translation from the French is mine.

21 For a discussion of color in weaving, see Becker, *Amazigh Arts in Morocco*, 35. She notes that the Aït Kabash women in Morocco divide colors in a light-dark dichotomy, and that light colors are always placed beside dark ones. Light colors are red and yellow (referring to sunlight), and dark colors are black and green (referring to darkness).

22 Slaoui, *Parures en Or du Maroc*, 32.

23 Ibid., 33.

24 Ibid., 22.

25 Ibid., 216–17.

26 Henriette Camps-Fabrer, *Bijoux Berbères d'Algérie* (Aix-en-Provence Édisud, 1990), 17.

27 Grammet, "Les Bijoux," 216.

28 Paul Eudel, *L'Orfèvrerie Algérienne et Tunisienne* (Alger: Editions Adolphe Jourdan, 1902), 162.

29 Gérard Santolini, "Les Bijoux Traditionels aux Maroc," typescript, 2002.

30 The "Ram Head" seal only became the norm for silver objects in October 1925. See Marie-Rose Rabaté and André Goldenberg, *Bijoux du Maroc* (Aix-en-Provence: Édisud, 1999), 200.

31 Grammet, "Les Bijoux," 213.

32 Camps-Fabrer, *Bijoux Berbères d'Algérie*, 21.

33 Grammet, "Les Bijoux," 244.

34 Camps-Fabrer, *Bijoux Berbères d'Algérie*, 9.

35 Grammet, "Les Bijoux," 217.

I would like to thank Gabriel Ringhilescu for his assistance securing information on the objects in this exhibition, Emma R. Bini for cataloguing object photographs, and Lisbeth Loughran, John Cooper, Mary Jo Arnoldi, Enid Schildkrout, and Donna Ghelerter for their thoughtful comments.

SELECTED BIBLIOGRAPHY

Alberini, Elena Schenone. *Libyan Jewellery. A Journey Through Symbols*. Cannara: Araldo de Luca, 1998.

Barthélémy, Anne. Tazra. *Tapis & Bijoux de Ouarzazate*. Aix-en-Provence: Édisud, 1990.

Becker, Cynthia J. *Amazigh Arts in Morocco: Women Shaping Berber Identity*. Austin: University of Texas Press, 2006.

Belkaïd, Leyla. *Algéroises: Histoire d'un Costume Méditerranéen*. Aix-en-Provence: Édisud, 1998.

Benfoughal, Tatiana. *Bijoux & Parures d'Algérie: Histoire, Techniques, Symboles*. Paris: Somogy Editions d'Art, 2003.

_____. *Bijoux et Bijoutiers de l'Aurès*. Paris: CNRS Editions, 1997.

Benjamin, Roger. *Orientalist Aesthetics. Art, Colonialism, and French North Africa. 1880–1930*. Berkeley: University of California Press, 2003.

Besancenot, Jean. *Costumes du Maroc*. 1942. Reprint. Aix-en-Provence: Édisud, 2000.

Biebuyck, Daniel P., and Nelly Van den Abbeele. *The Power of Headdresses: A Cross-Cultural Study of Forms and Functions*. Brussels: Tandi S.A., 1984.

Camps, Gabriel. *Les Berbères. Mémoire et Identité*. Paris: Éditions Errances, 1995.

Camps-Fabrer, Henriette. *Bijoux Berbères d'Algèrie*. Aix-en-Provence: Édisud, 1990.

Champault, Dominique, and Arnaud Raymond Verbrugge. *La Main: Ses Figurations au Maghreb et au Levant*. Paris: Musée d'Histoire Naturelle, 1965.

Eudel, Paul. *L'Orfèvrerie Algérienne et Tunisienne*. Algers: Éditions Adolphe Jourdan, 1902.

Gargouri-Sethom, Samira. *Le Bijou Traditionel en Tunisie*. Aix-en-Provence: Édisud, 1986.

Gonzalez, Valérie. *Emaux d'al-Andalus et du Maghreb*. Aix-en-Provence: Édisud, 1994.

Grammet, Ivo. "Les Bijoux." In *Splendeurs du Maroc*. Tervuren: Musée Royal de l'Afrique Centrale, 1998.

Horneman, Frederick. *The Journal of Frederick Horneman's Travels, from Cairo to Mourzouk, the Capital of the Kingdom of Fezzan, in Africa in the Years 1797–8*. 1802. Reprint. London: Darf Publishers Limited, 1985.

Jereb, James F. *Arts and Crafts of Morocco*. New York: Thames and Hudson, 1995.

L'Africain, Jean-Leon. *Description de l'Afrique*. Trans. from the Italian by A. Epaulard, 2 Vols. 1956. Reprint. Paris: J. Maisonneuve, 1981.

Marchesani, Ileana, Franco D'Alessandro, and Mériem Othmani. *Tizerzaï: La Fibule au Maroc*. Milano: Edition Sicopa, 1987.

Rabaté, Jacques and Marie-Rose. *Bijoux du Maroc. Du Haut Atlas à la vallée du Draa*. Aix-en-Provence: Édisud/Le Fennec, 1996.

Rabaté, Marie-Rose, and André Goldenberg. *Bijoux du Maroc. Du Haut Atlas a la Méditerranée. Depuis le temps des juifs jusqu'à la fin du XXe Siècle*. Aix-en-Provence: Édisud, 1999.

Ramirez, Francis, and Christian Rolot. *Bijoux du Maroc. La Beauté des Diables*. Courbevoie/Paris: ACR Edition Internationale, 2002.

Rouach, David. *Bijoux Berbères au Maroc dans la Tradition Judeo-Arabe*. Courbevoie/Paris: ACR Edition, 1989.

Santolini, Gérard. 2002. *Les Bijoux Traditionels aux Maroc*. Typescript.

Schaffar, Jean-Jacques. *Gioielli e Misteri dei Berberi*. Milano: Art World Media, Srl, 1990.

Slaoui, Abderrahman. *Parures en Or du Maroc: Trésors des Cités Impériales*. Barcelona: Malika Editions, 1999.

Tamzali, Wassyla. *Abzim: Parures et Bijoux des Femmes d'Algérie*. Paris: Dessain et Tolra, 1984.

Thornton, Lynne. *The Orientalists: Painters-Travellers*. Paris: ACR Edition, 1994.

Untracht, Oppi. "Materials and Techniques." In *Ethnic Jewelry*, ed. John Mack. New York: Harry N. Abrams, 1988.

METALWORK TECHNIQUES

Annealing: a toughening process whereby metal is exposed to continuous and slowly diminishing heat.

Bezel settings: used to hold stones and gems and made with rectangular, square, oval, or round rims to follow the shape of the stones; the rims are hammered around the stones to keep them in place and some bezel settings have small teeth to secure the stones.

Casting and lost-wax casting: the process of pouring metal into a mold to give it a definite shape. For lost-wax casting, jewelers fashion a piece in wax, then coat it with a clay paste. When the clay is dry, it is heated to melt the wax. The mold is then filled with heated metal. Once cool, the clay is cracked open to reveal the cast object.

Champlevé: used with enamel work, where enamel is poured into grooves engraved on the surface of the object in a decorative pattern.

Chasing: the tooling of metal, with hammers and tools, to incise, punch, and trace surface designs.

Cloisonné: used with enamel work, where enamel is poured into compartments formed by small strips of metal soldered to the object's surface in a decorative pattern.

Cold forging: used to stretch, shrink, taper, or bend metal by hammering it on an anvil.

Doming: a process used by jewelers to create hollow hemispheres; a sheet of metal placed on a doming block is hammered into a depression with a ball-ended doming punch.

Embossing and repoussé: relief decorations on metal produced by hammering from the reverse side. Designs are completed on the front side with hammers and engraving tools.

Enameling: a technique involving the use of powdered glass that is diluted with water and binders and fused to a metal surface under heat.

Engraving: the process of decorating a metal surface, whereby jewelers remove some metal from the surface of the object to create inscribed designs.

Filigree: a decorative technique used to create openwork designs with gold or silver wire, either soldered onto a metal surface or done without a background.

Gilding: the process of decorating a metal surface with gold leaf or gold powder.

Granulation: the process of decorating a metal surface with small metal balls.

Metal inlay: used to place a different colored metal onto the surface of an object; for wire inlay, wire is placed inside grooved designs and secured by hammering.

Niello: a black substance composed of copper, lead, silver, sulfur, and borax that is used to fill incised decorations on silver. The mixture is poured into the decorative grooves and fixed by the application of heat.

Opus interrasile: a decorative technique using piercing to create designs and motifs.

Piercing: the process of perforating metal to create decorative designs.

HEAD ORNAMENTS

The headdresses, diadems, headbands, forehead ornaments, and hair decorations worn by women in the Maghreb are valuable prestige pieces. Women in urban centers wear headbands made with pearls and semi-precious stones, while women from the oases make their ornaments out of incised shells or leather plaques embellished with shell and glass beads. Silver and enamel pendants, coins, and beads dangle from headbands of cotton, leather, or silk. Forehead ornaments are decorated with a central plaque, embellished with pendants, and worn at the middle of the forehead.

1 *Conical Headdress*
 (Tadj Chechia)
 19th or 20th century
 North Africa
 Silver

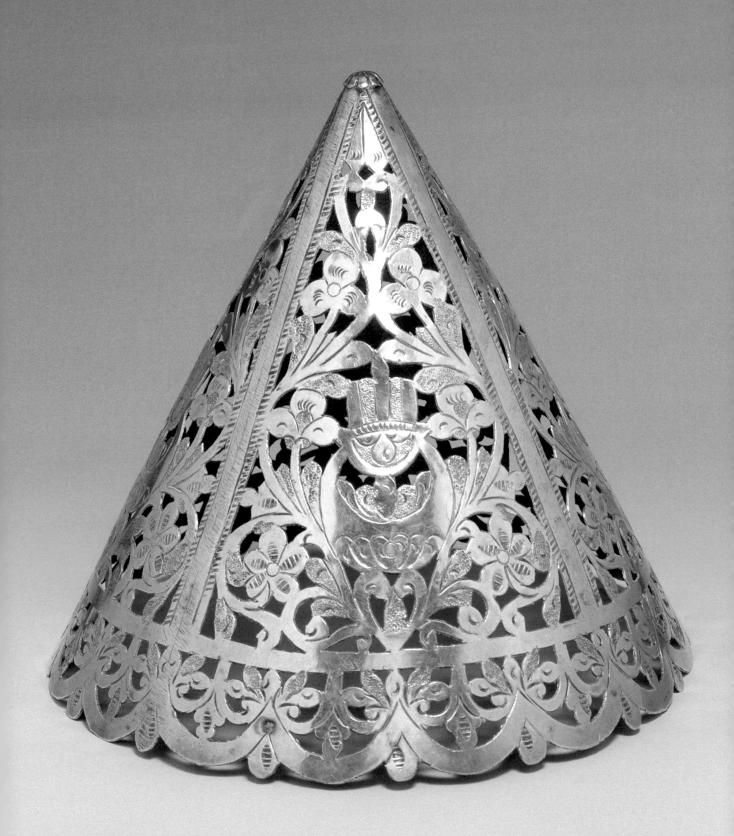

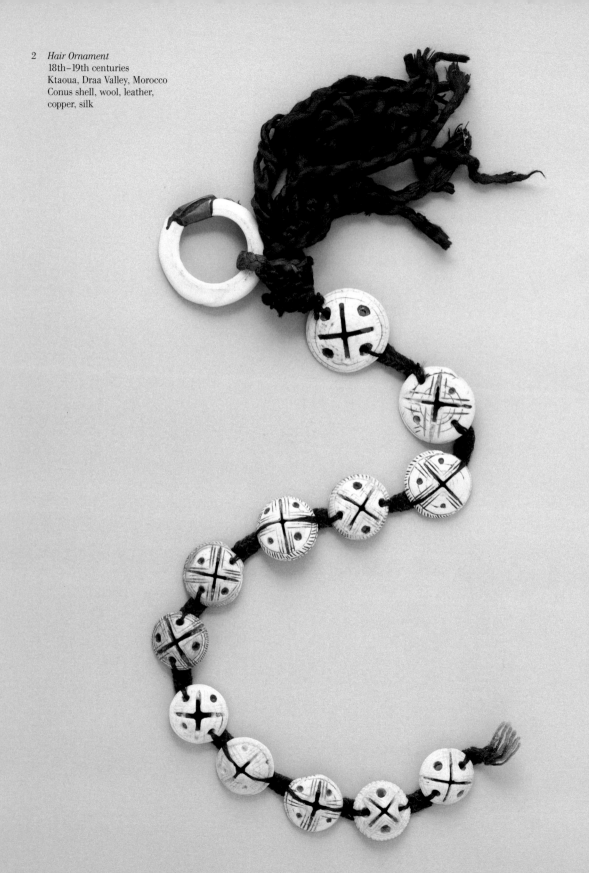

2 *Hair Ornament*
18th–19th centuries
Ktaoua, Draa Valley, Morocco
Conus shell, wool, leather,
copper, silk

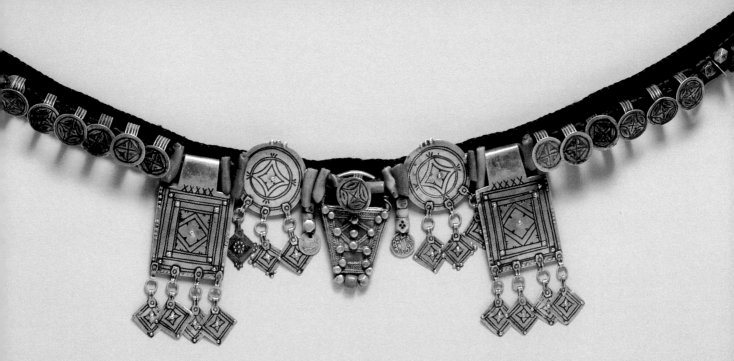

3 *Headband*
 20th century (with some
 19th-century elements)
 Bani Oasis, Jebel Bani, Morocco
 Silver, coral, enamel, copal,
 amazonite, glass, wool

4 *Headband*
 19th century
 Bani Oasis, Jebel Bani, Morocco
 Copal, coral, silver, enamel, coins,
 glass, cotton, buttons

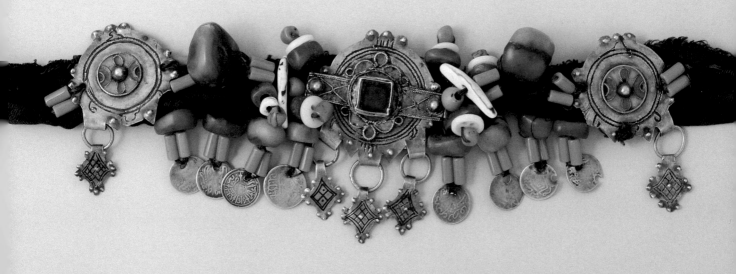

EARRINGS

Earrings, often worn attached to the hair and covering the ears, are precious heirlooms. Gold or gilded hoops, decorated with precious and semi-precious stones and pearls, or embellished with coral pendants, appear in urban centers. Earrings from rural areas are usually large hoops, sometimes augmented with pendants and beads. Some earrings take the form of heavy plaques, similar to those that make up head ornaments. Women often hang these from wool threads at either side of their temples.

5 *Earrings*
 Early 20th century
 Aït Horbil people
 Western Anti-Atlas, Morocco
 Silver, enamel, stone

6 *Hoop Earrings*
 19th or 20th century
 Tunisia, Morocco
 Silver

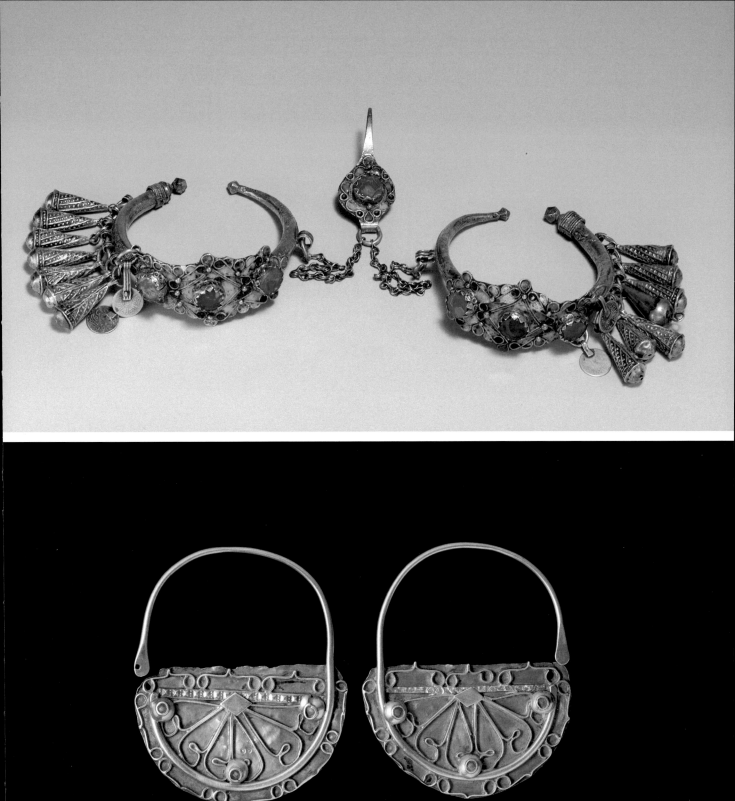

NECKLACES

North African women are masters of the art of assembling and making necklaces. They purchase the necessary elements from jewelers—beads of stones, glass, and colorful enamel patterns, as well as pendants in many shapes. While there are classical necklace styles determined by ethnic group, women create unique items reflecting their personal artistic choices.

Some women incorporate only select materials in their necklaces, such as amazonite beads or highly valued large amber beads, symbolizing wealth and attributed with protective and medicinal properties. Other necklaces combine myriad elements, including pendants and the enameled beads known as *tagguemout,* which are thought to represent fertility. Some design features of the necklaces, such as the *tagguemout* beads from the Tiznit area, and pendants and niello plaques favored by the Ida Ou Nadif, indicate regional and group identity.

7 *Three-Strand Necklace*
Late 20th century (some 19th-century elements)
Aït Atta people
Jebel Sarhro, Morocco
Amber or copal, wool, metal rosettes

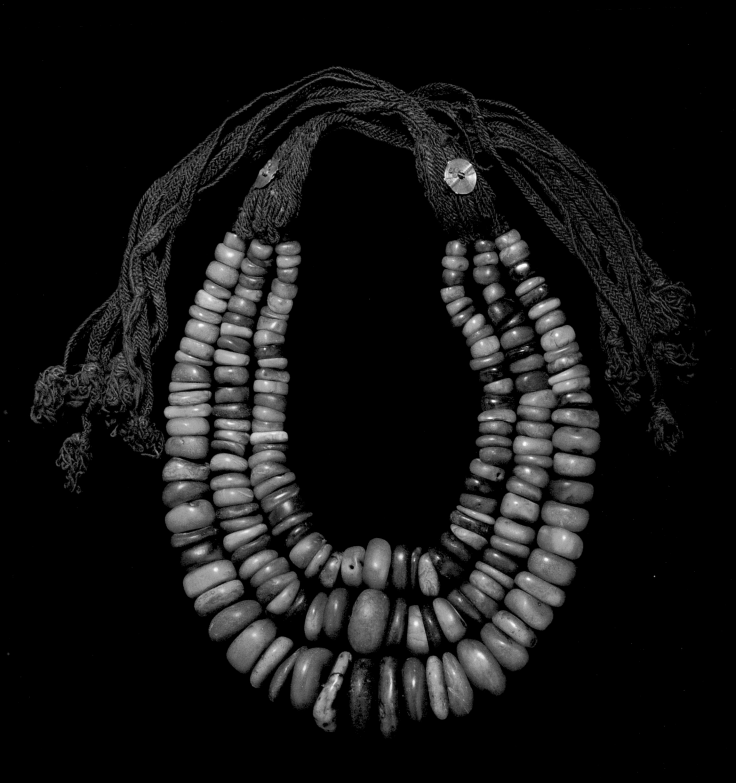

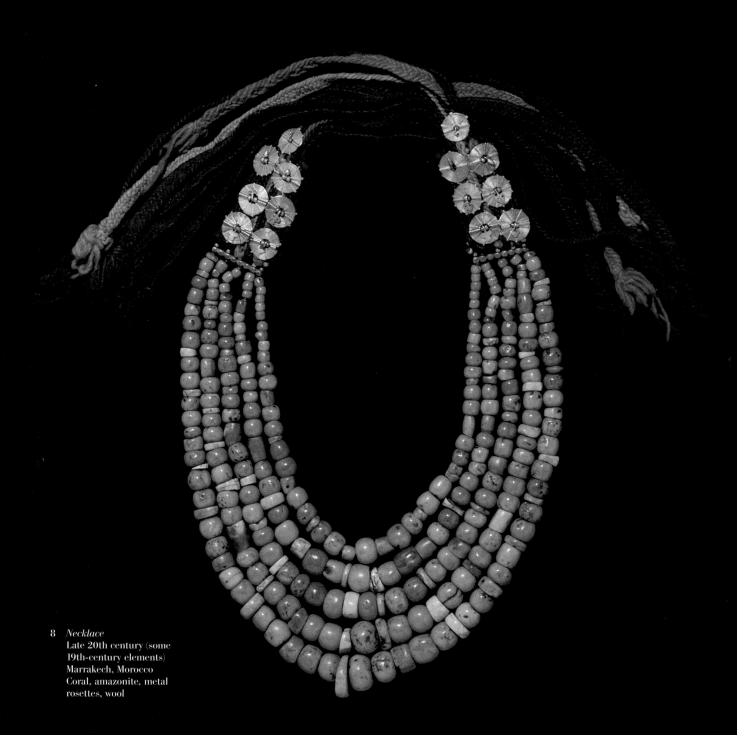

8 *Necklace*
Late 20th century (some
19th-century elements)
Marrakech, Morocco
Coral, amazonite, metal
rosettes, wool

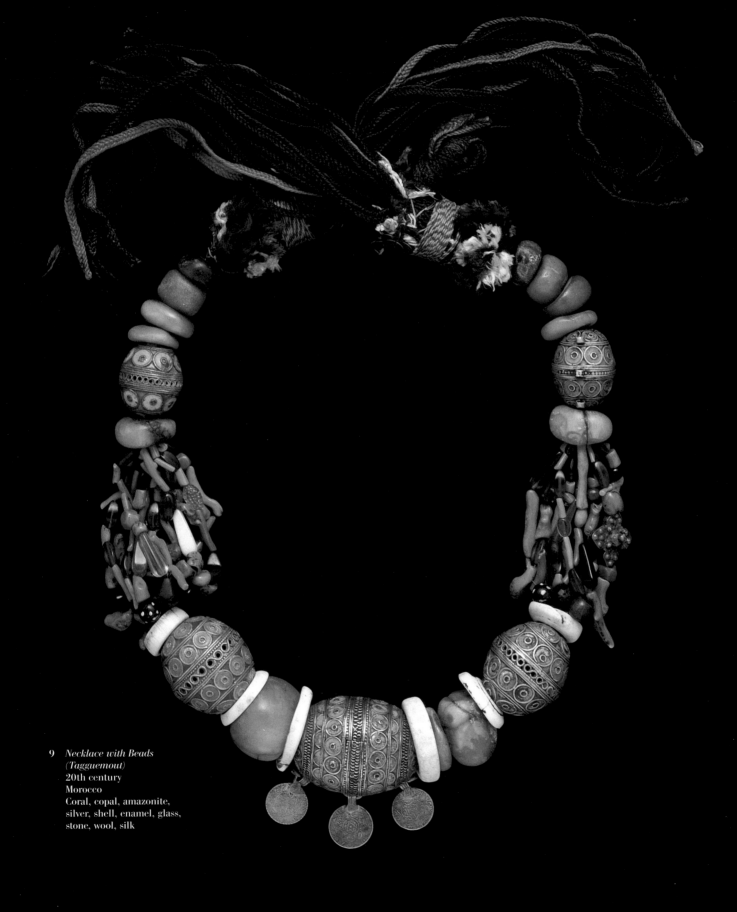

9 *Necklace with Beads
(Tagguemout)*
20th century
Morocco
Coral, copal, amazonite,
silver, shell, enamel, glass,
stone, wool, silk

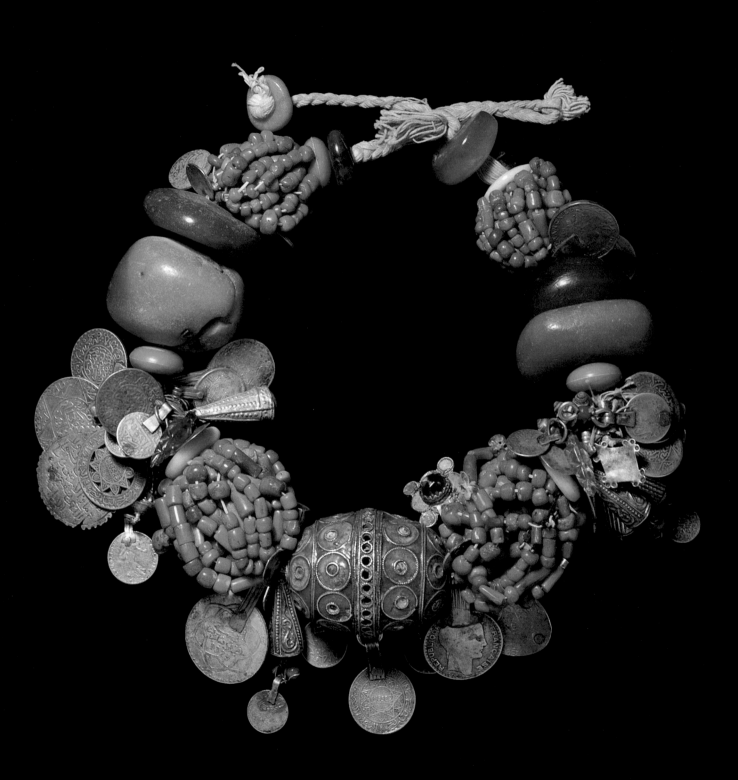

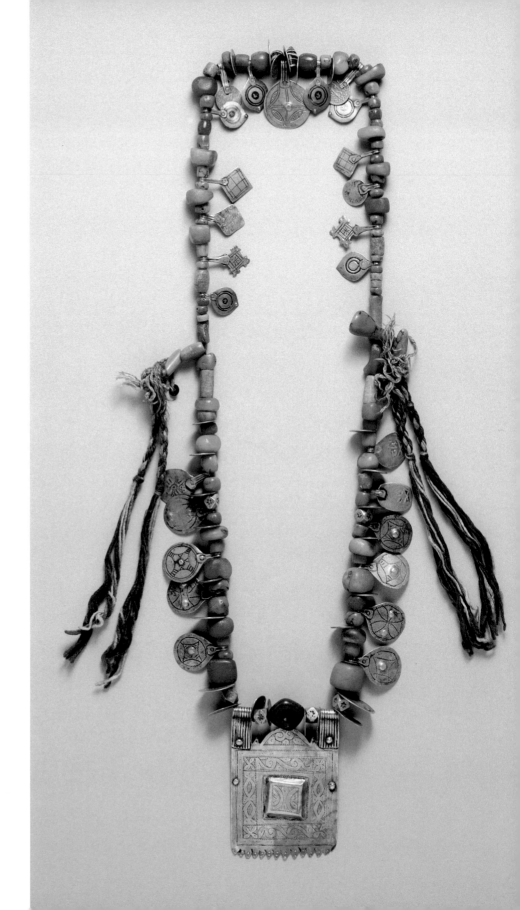

10 *Necklace with Central Pendant*
(Tagguemout)
20th century
Draa Valley, Morocco
Silver, copper, coral, enamel,
coins, glass, copal, shell,
cotton, plastic, buttons

11 *Necklace with Square Pendant*
Late 20th century
Marrakech, Morocco
Silver with niello decoration,
amazonite, silver coins, coral,
amber, shells, wool

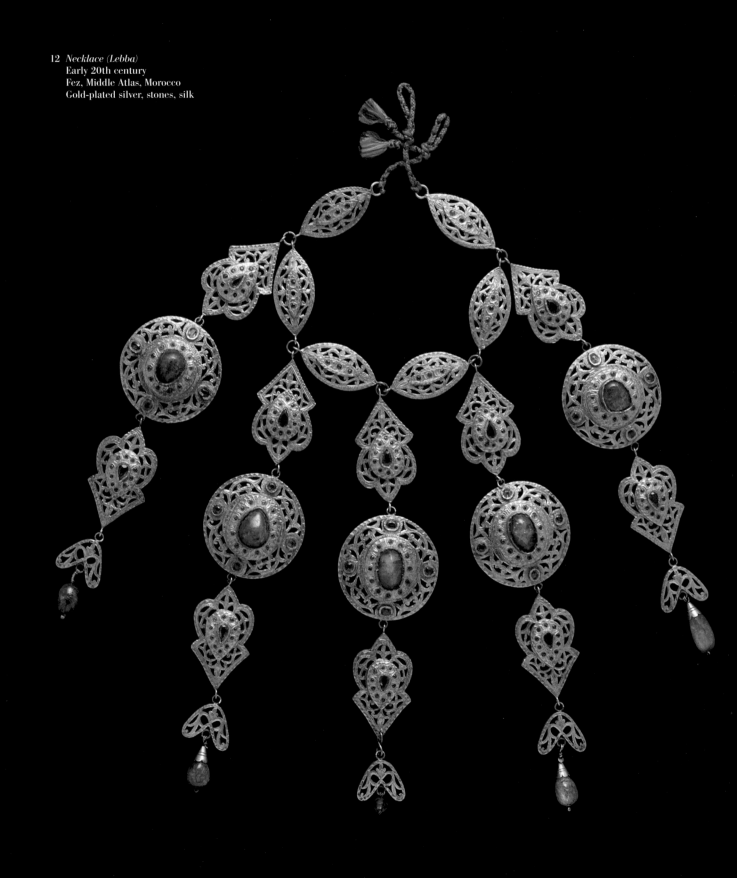

12 *Necklace (Lebba)*
 Early 20th century
 Fez, Middle Atlas, Morocco
 Gold-plated silver, stones, silk

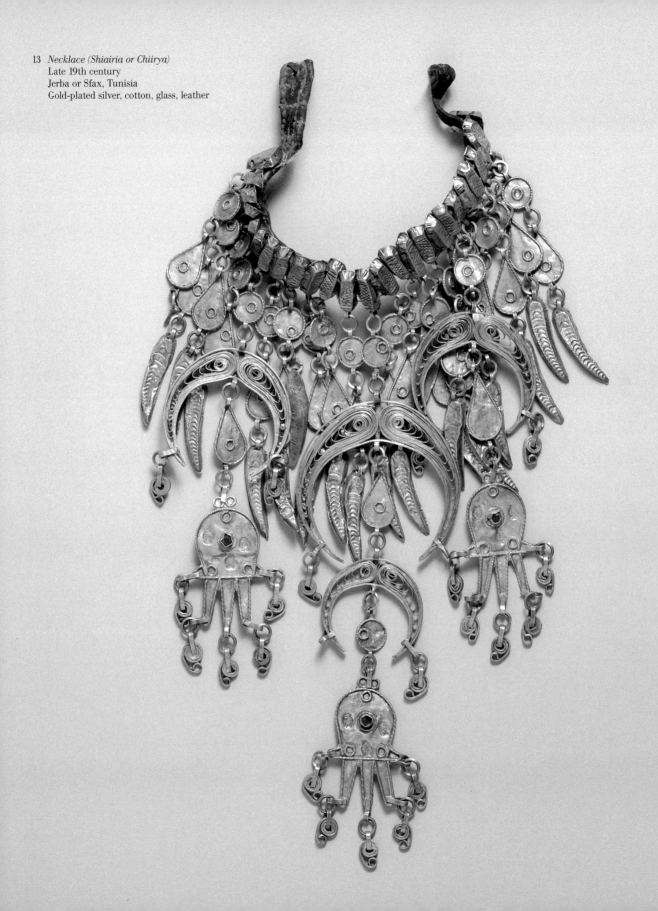

13 *Necklace (Shiairia or Chiirya)*
Late 19th century
Jerba or Sfax, Tunisia
Gold-plated silver, cotton, glass, leather

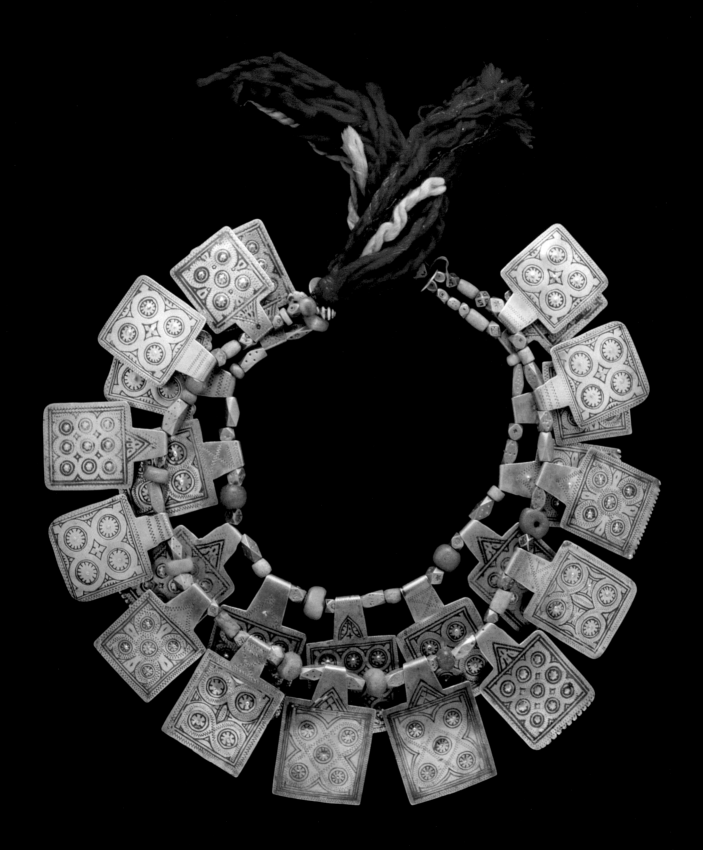

14 *Necklace*
 Late 20th century
 Ida Ou Nadif style
 Marrakech, Morocco
 Silver with niello decoration,
 amazonite, amber, glass,
 wool, silk

15 *Necklace*
 Late 20th century
 Western Anti-Atlas, Morocco
 Silver with niello decoration,
 coral, wool

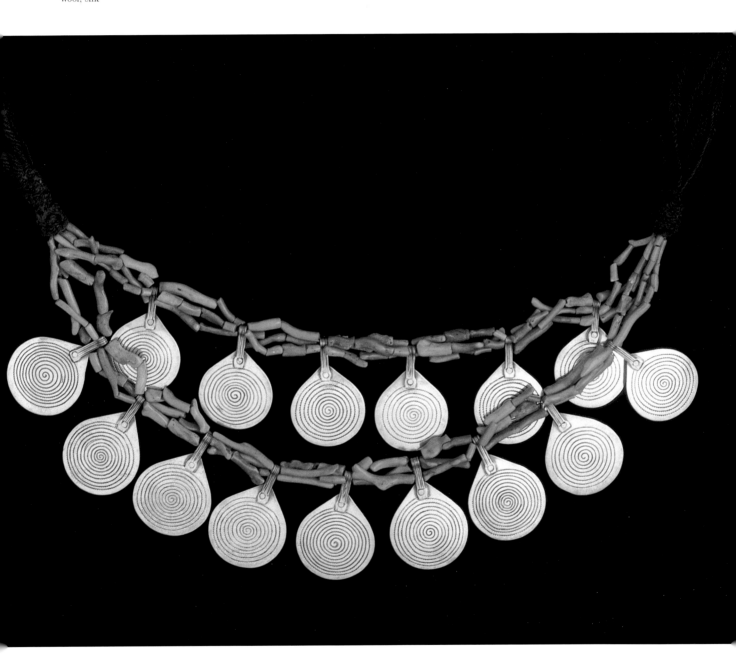

AMULETS AND PENDANTS

Amulets and protective pendants beautify and protect the wearer. Sometimes hung on leather strands and worn close to the body or assembled with other pendants into necklaces, these tokens are essential elements of Amazigh jewelry. Small cases containing magical numbers and religious inscriptions also serve to deflect harm.

In North Africa, hand amulets (*khamsa*), typically made of silver, are the most popular form of protective jewelry. The arrangements of fingers on the hands appear in differing configurations: four fingers and an upturned thumb, three fingers and an upturned thumb on either side, or five parallel fingers. Most hands are decorated with arabesques and floral designs; some are embellished with smaller hands, swords, or animal motifs. Hands are considered beneficial because of the number five: uneven numbers are thought of as favorable, and the number five is also associated with the five pillars of Islam. *Khamsa* are sometimes engraved with prayers and inscriptions in Arabic or Hebrew.

16 *Necklace with Central Hand Pendant (Khamsa)*
Late 20th century
Morocco
Silver, coral, horn

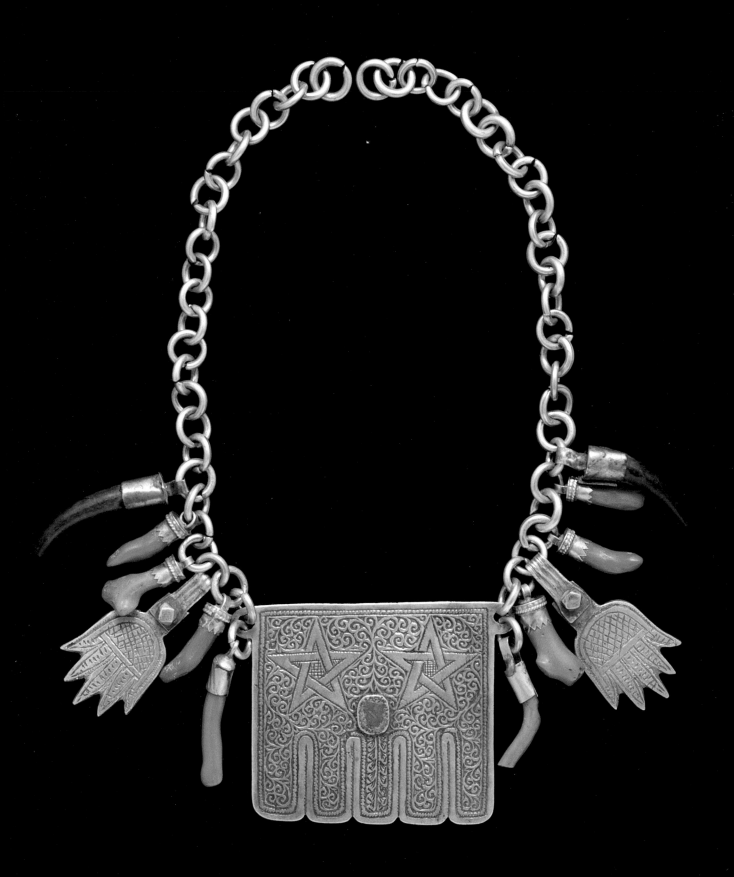

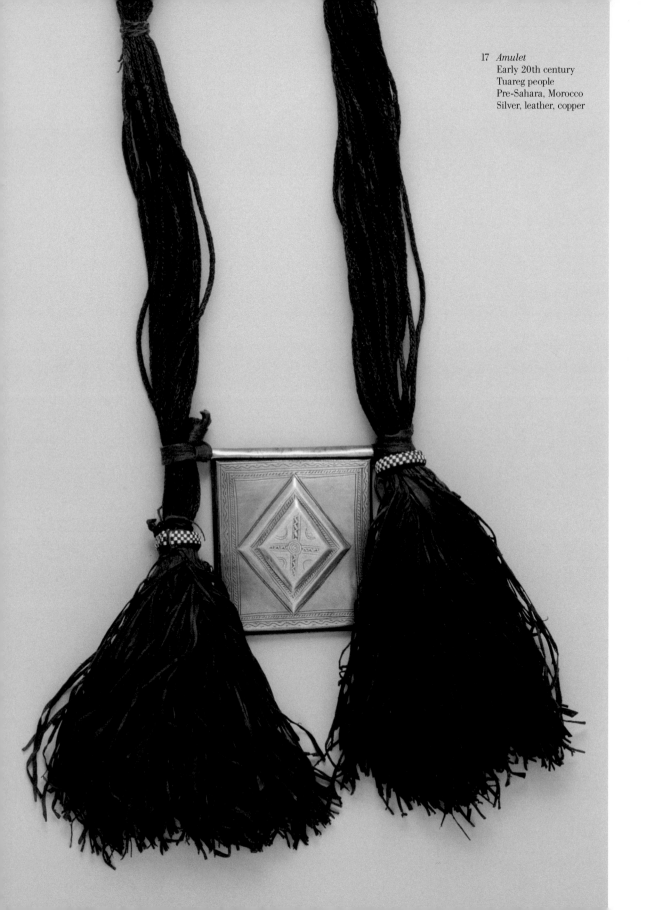

17 *Amulet*
Early 20th century
Tuareg people
Pre-Sahara, Morocco
Silver, leather, copper

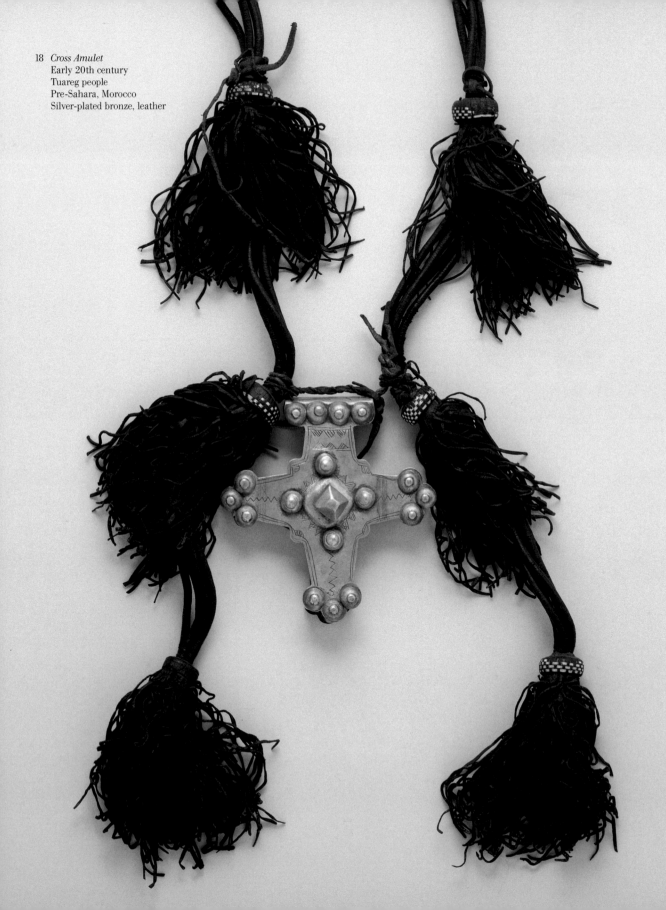

18 *Cross Amulet*
 Early 20th century
 Tuareg people
 Pre-Sahara, Morocco
 Silver-plated bronze, leather

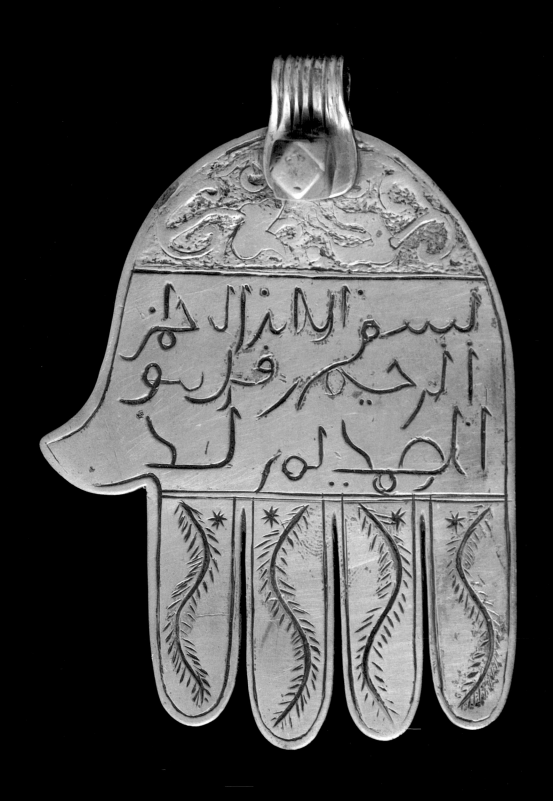

19 *Hand Pendant (Khamsa) with*
Arabic Inscription
19th or 20th century
Morocco
Silver

The Arabic inscription reads:
The name of Allah, the most gracious,
the most merciful,
He is God the One and Only,
self sufficient, He begot not.

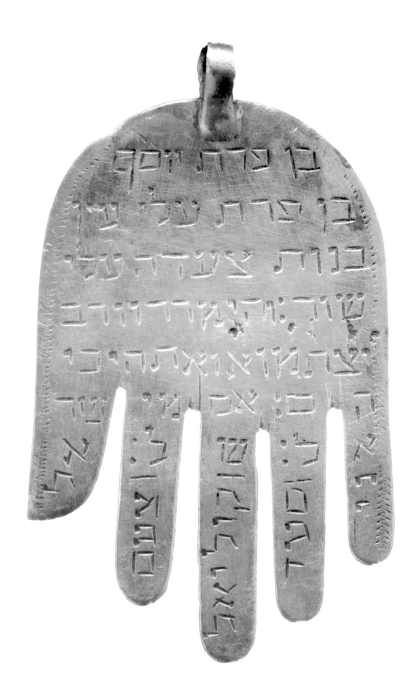

20 *Hand Pendant (Khamsa) with*
Hebrew Inscription
19th or 20th century
Morocco
Silver

The inscription on this hand amulet
opens with a verse from Jacob's
blessing of his children in the book
of Genesis (49:22): "Joseph is a fruit-
ful bough, a fruitful bough by spring,
its branches run over a wall." It then
continues on with a portion of the
next verse (49:23): "They embittered
him and became protagonist." The
reference to this verse likens the
wearer to Joseph, a biblical personal-
ity who overcame many obstacles
before achieving success.

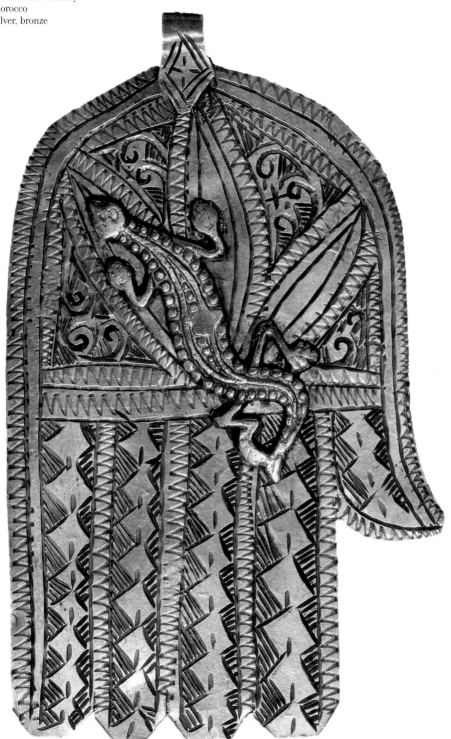

21 *Hand pendant (Khamsa)*
 with Salamander Motif
 19th or 20th century
 Morocco
 Silver, bronze

22 *Hand pendant (Khamsa)*
 with Six-Pointed Star
 19th or 20th century
 Morocco
 Silver plated

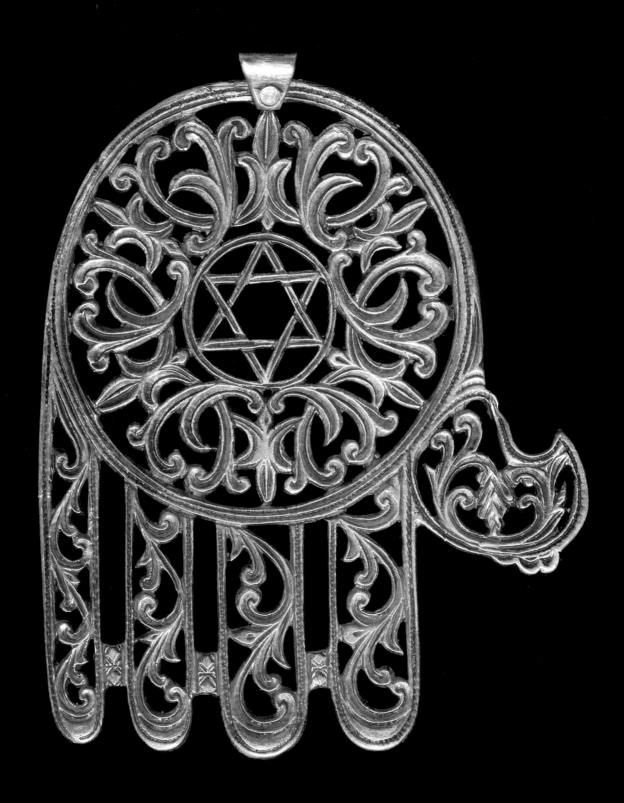

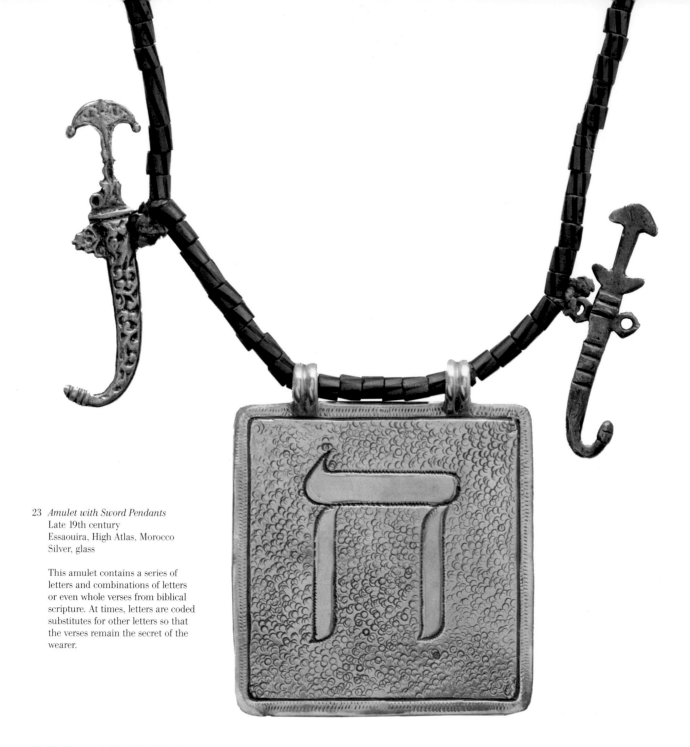

23 *Amulet with Sword Pendants*
Late 19th century
Essaouira, High Atlas, Morocco
Silver, glass

This amulet contains a series of
letters and combinations of letters
or even whole verses from biblical
scripture. At times, letters are coded
substitutes for other letters so that
the verses remain the secret of the
wearer.

24 *Necklace with Three Hand Pendants
(Khamsa), and Snake Motif*
19th or 20th century
Morocco
Silver with niello decoration,
stone, wax

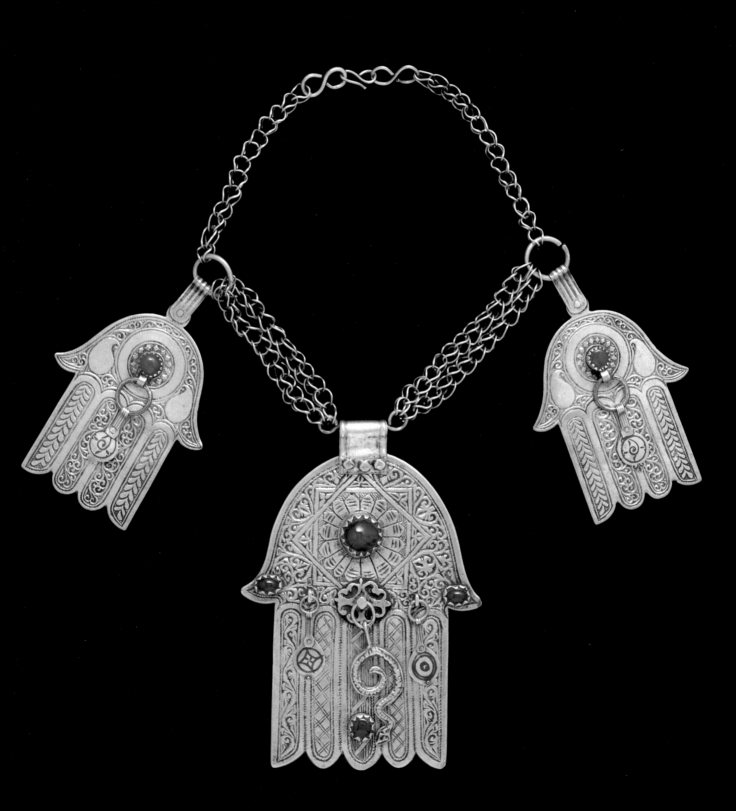

25 *Pendant (Herz)*
 19th or 20th century
 Western Anti-Atlas, Morocco
 Silver, enamel, glass

26 *Pendant*
 20th century
 Tuareg people
 Sahara, Morocco
 Silver, agate

BELT BUCKLES

Belt buckles, referred to as *fakroun* (turtle) because of their shape, are usually a gift from a groom to his bride. Urban examples are often made of silver and gilt silver, decorated with semi-precious stones and typically featuring motifs of animals or hands. Belts were once made of embroidered silk, and the buckles were used to emphasize a woman's waist.

27 *Belt Buckle*
 19th or 20th century
 Essaouira, Morocco
 Silver

28 *Belt Buckle*
 19th or 20th century
 Meknès style
 Morocco
 Gold plated, enamel

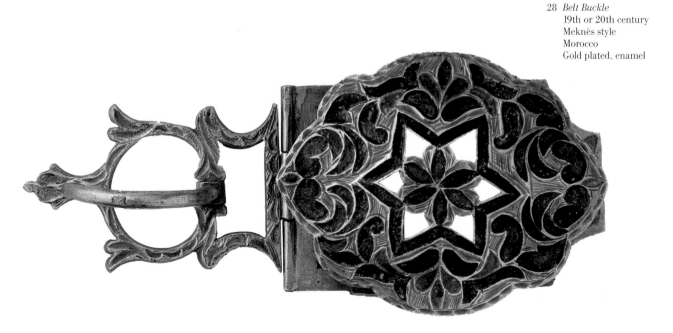

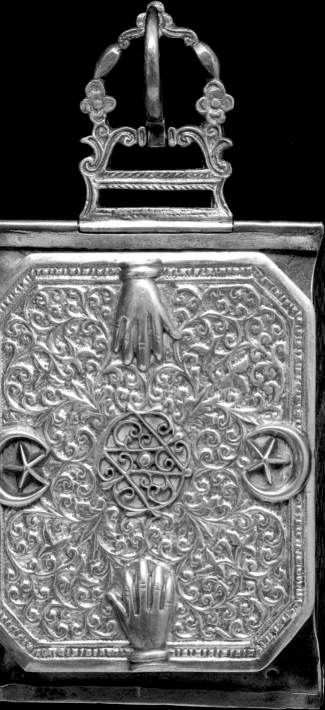

FIBULAE

Women throughout the Maghreb use fibulae (*tizerzaï*), of various sizes and construction according to their ethnic group, to fasten their garments. Made of long pins and a circular open ring attached to a decorated base, fibulae are worn in identical pairs. The pin is thought to protect the wearer against the evil eye, and the inverted triangular lower sections symbolize the female form. Large examples are sometimes connected with chains to central beads or pendants. Fibulae designs emphasize symmetry and draw attention to the movement created by the chains and pendants when women move. Gold fibulae made in urban areas are often embellished with precious and semi-precious stones.

29 *Fibulae (Tizerzaï) with Central
 Pendant (Tagguemout)*
 Late 19th century
 Ida Ou Semlal people
 Anti-Atlas, Morocco
 Silver, enamel, coins, glass

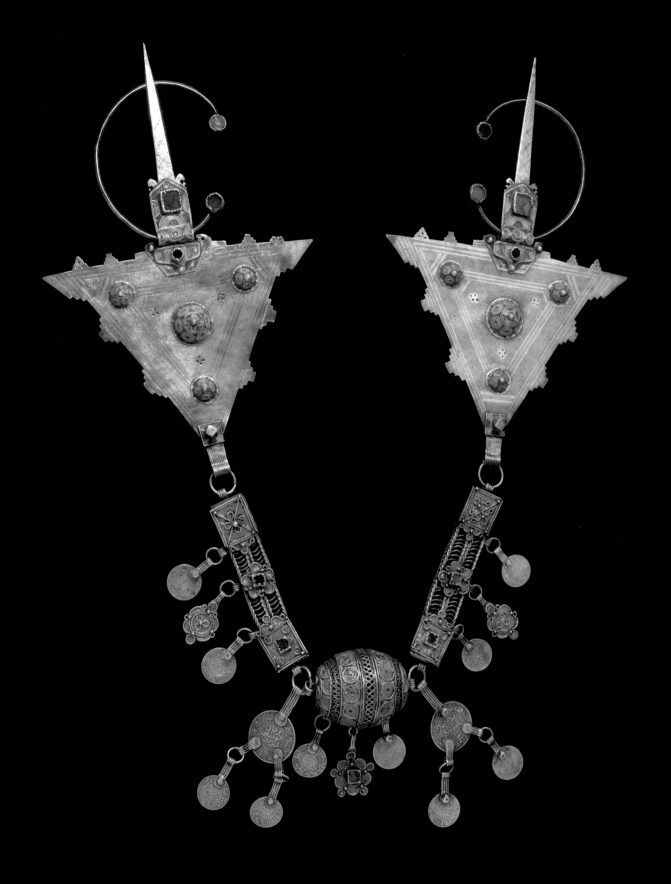

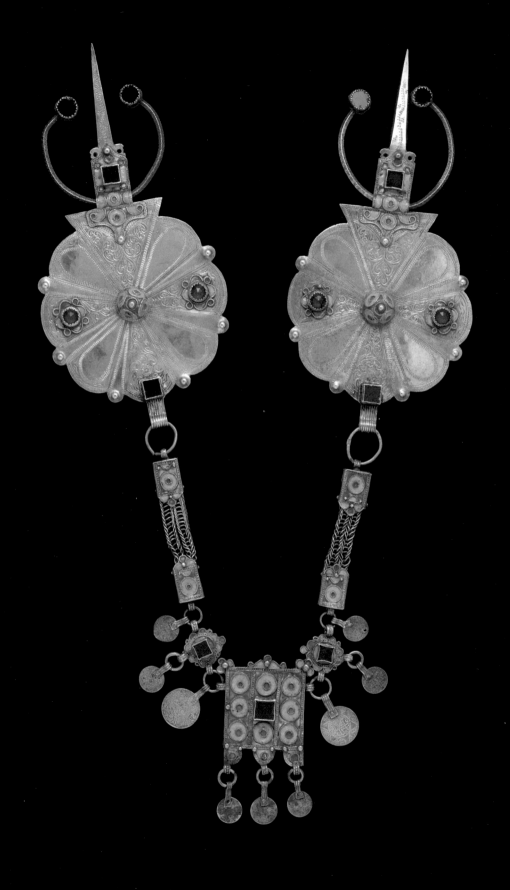

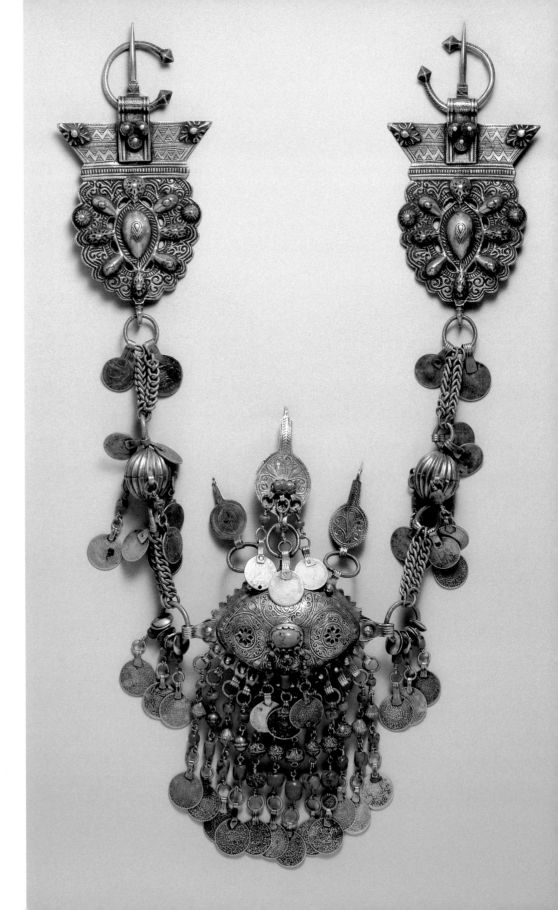

30 *Fibulae*
20th century
Tiznit, Morocco
Silver, enamel, coins, glass

31 *Fibulae (Tizerzaï) with*
Central Pendant (Fekroun)
Late 19th century
Jebel Rif, Morocco
Silver, coral, coins

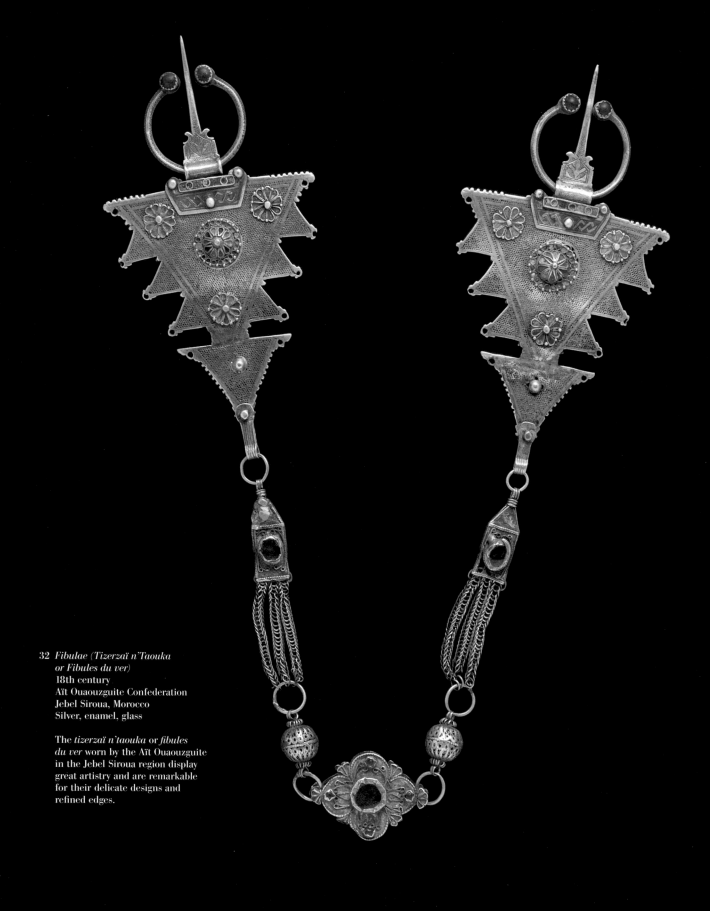

32 *Fibulae (Tizerzaï n`Taouka
or Fibules du ver)*
18th century
Aït Ouaouzguite Confederation
Jebel Siroua, Morocco
Silver, enamel, glass

The *tizerzaï n`taouka* or *fibules
du ver* worn by the Aït Ouaouzguite
in the Jebel Siroua region display
great artistry and are remarkable
for their delicate designs and
refined edges.

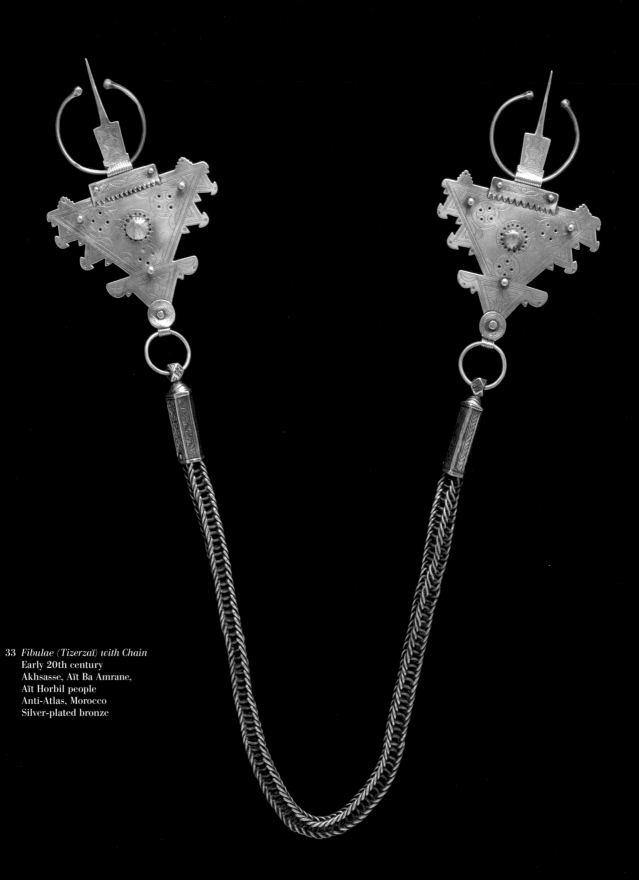

33 *Fibulae (Tizerzaï) with Chain*
Early 20th century
Akhsasse, Aït Ba Amrane,
Aït Horbil people
Anti-Atlas, Morocco
Silver-plated bronze

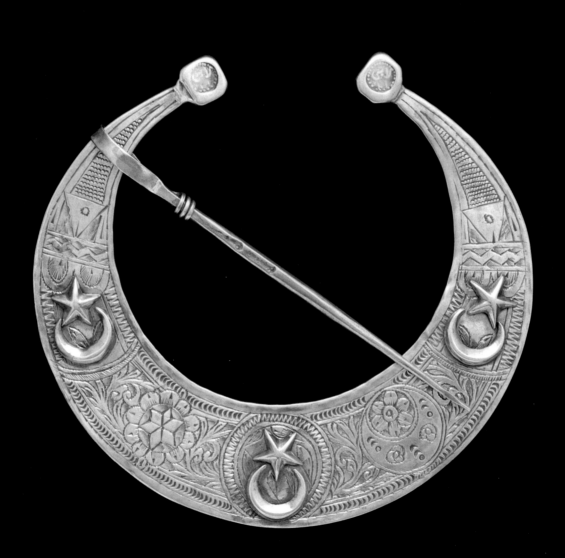

34 *Half Moon Fibula (Hillal)*
19th century
Medenine or Tataouine, Tunisia
Silver

Women in Tunisia wear elegant
hillals, silver ornaments shaped as
crescent moons and often decorated
with fish and star motifs.

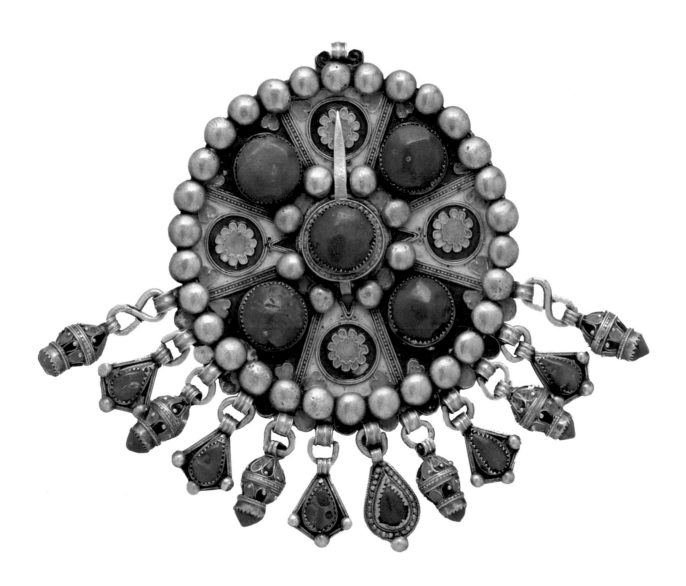

35 *Fibula (Tabzimt)*
Late 19th century
Aït Yenni people
Great Kabylie, Algeria
Silver, coral, enamel

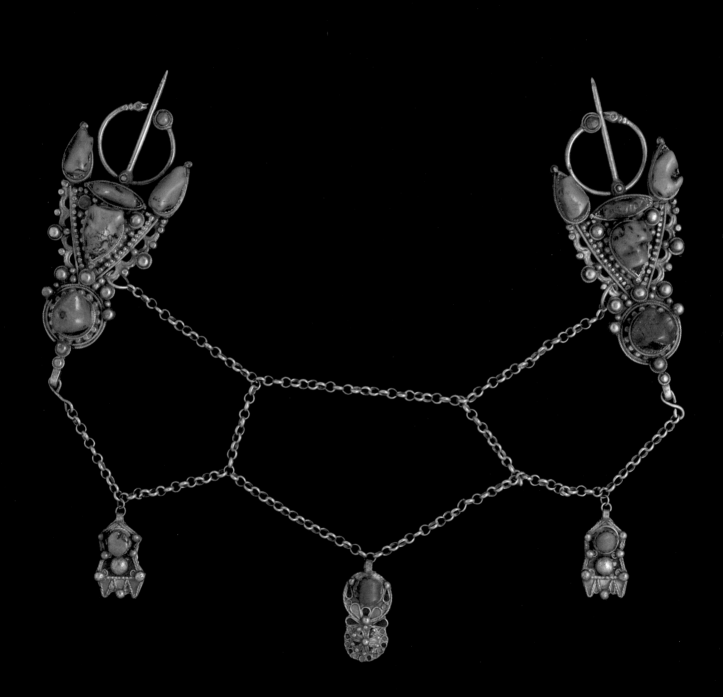

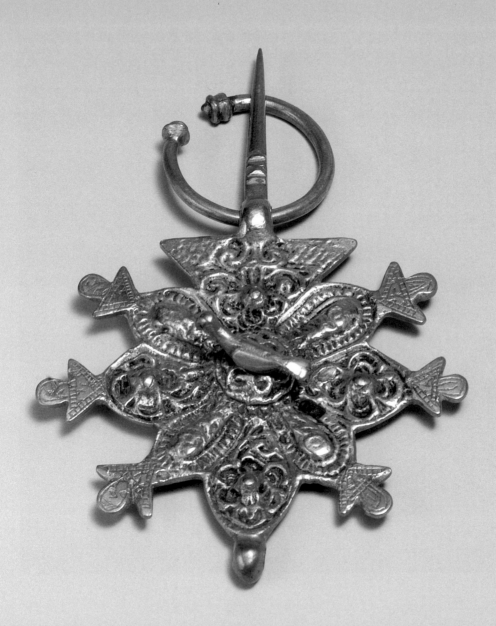

36 *Fibulae (Abzim)*
 19th–20th centuries
 Aït Yenni people
 Great Kabylie, Algeria
 Silver plated, coral,
 enamel

37 *Fibula with Bird (Tisernas)*
 19th or 20th century
 Aït Haddidou people
 Central High Atlas, Morocco
 Silver

38 *Fibulae with Containers*
 19th or 20th century
 Morocco
 Silver plated

 The containers were possibly
 used for aromatic herbs.

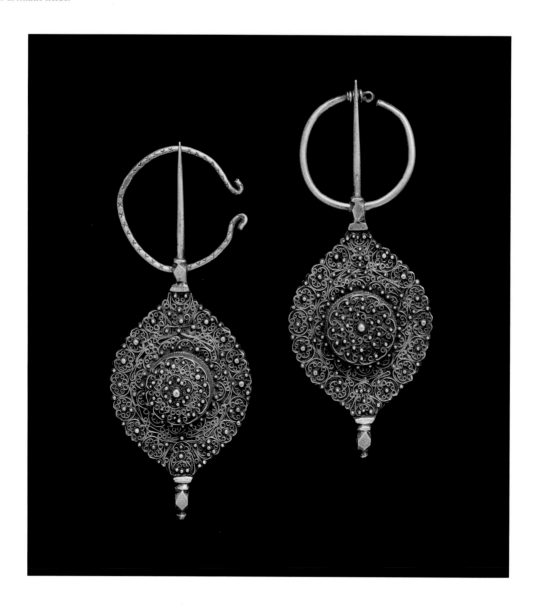

39 *Fibulae*
 20th century
 Marrakech, Morocco
 Gold-plated silver, coins

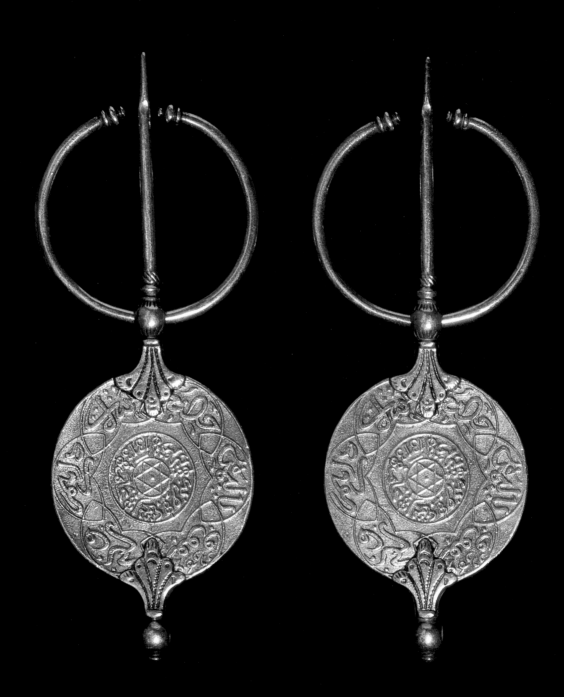

BRACELETS

Pairs of bracelets often appear on the arms of women in the Maghreb. Bold and graphic, the spiked silver bracelets known as "bracelets of the horns" (*izbian n'iqerroin*) adorn Aït Atta women in the Jebel Sarhro region of Morocco. Bracelets known as *chems ou qmar* or *lune et soleil* are classic forms, with their elegant raised silver and gold designs. *Amesluh* bracelets worn by Aït Yenni women in Great Kabylie, Algeria, display bright red stones and refined engraving work. Open-ended bracelets are reserved for young women, and ankle bracelets, once common in most parts of Morocco, are now worn only in the Pre-Saharan regions.

40 *Large Bracelet*
 (Amesluh)
 19th or 20th century
 Beni Yenni people
 Great Kabylie, Algeria
 Silver, enamel, coral

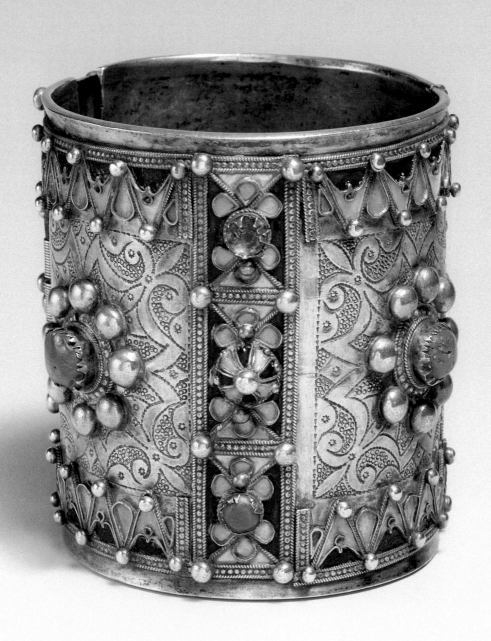

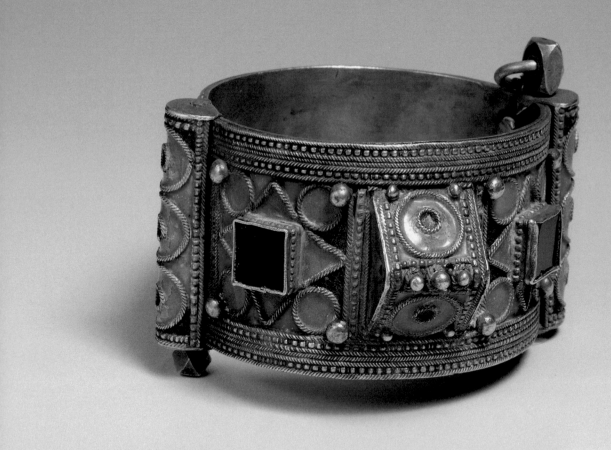

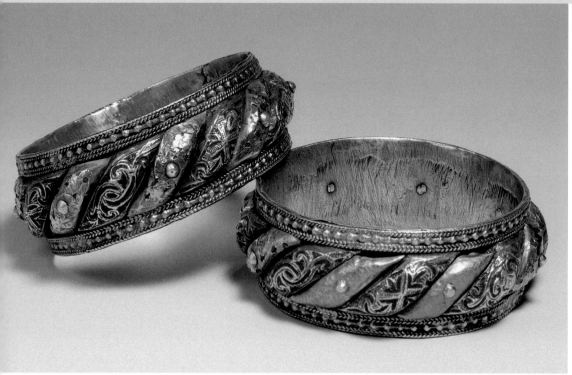

41 *Bracelet (Nbala or Tanbalt)*
Early 20th century
Ammeln people
Tiznit, Western
Anti-Atlas, Morocco
Silver, enamel, glass

42 *Bracelets (Chems Ou Qmar or Lune et Soleil)*
20th century
Tetouan, Ouezzane, or Fez, Morocco
Silver, gold, enamel

43 *Bracelet with Spikes (Izbian n'Iqerroin)*
 19th or 20th century
 Aït Atta people
 Jebel Sarhro, Morocco
 Silver-plated bronze

 These bracelets were worn in pairs, along
 with leather bangles, to protect the skin
 and were once used as weapons.

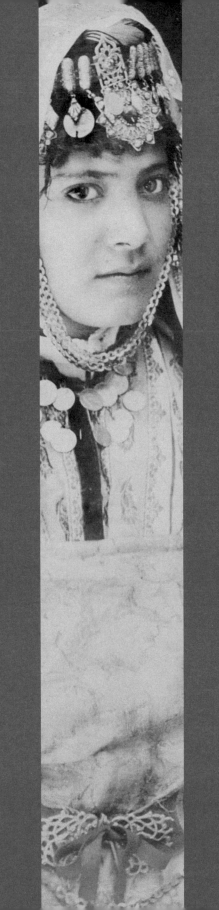

PHOTOGRAPHIC ENCOUNTERS ON THE NORTH AFRICAN STAGE

Cynthia Becker

THE PHOTOGRAPHS in the Xavier Guerrand-Hermès collection, many more than a century old, provide a fascinating glimpse into nineteenth-century North African society. Featuring Imazighen (also known as Berbers),[1] Arabs, Jews, and people from sub-Saharan Africa working as merchants, water sellers, musicians, and teachers, the photographs present the ethnic diversity and cosmopolitanism that still characterize North Africa. At the same time, the Guerrand-Hermès collection, containing works by some of the major figures in early photography, illuminates many of the formal trends in an emerging medium of visual communication. Above all, photography established a new way for Europeans to satisfy their fascination with the so-called Orient.

Almost immediately after the invention of the daguerreotype in 1839, intrepid photographers willingly carried their extraordinarily heavy cameras and equipment to North Africa. Battling technical difficulties, exacerbated by the region's intense heat and sandstorms, most early European photographic expeditions documented ancient archaeological sites and landscapes rather than the people and culture. Prints from these expeditions were mounted in large albums and given to dignitaries or sold to wealthy subscribers.[2]

By 1851, the development of the collodian glass-plate negative significantly reduced the long exposure times that restricted early photography. In the following decade, traveling European photographic expeditions gradually gave way to the establishment of commercial studios in the major cities and tourist trails of North Africa, especially in Algeria, which had been colonized by the French in 1830. By 1865, more than thirty European photographers were working in twelve Algerian cities.

44 *Portrait of a Man*
Pascal Sebah
North Africa, ca. 1870
10½ x 8¼ in.
Albumen print from a
collodion glass negative

Of Syrian/Armenian origin, Pascal Sebah (1823–1886) opened a studio in Constantinople in 1857. He established a branch studio in Cairo in 1873 near the celebrated Shepherd's Hotel. In 1878, Pascal Sebah won a silver medal at the Exposition Universelle for his photographs of Nubian desert tribes. He suffered a stroke in 1883, and his brother took charge of the studio until his son Jean (1872–1947) was old enough to inherit the business.

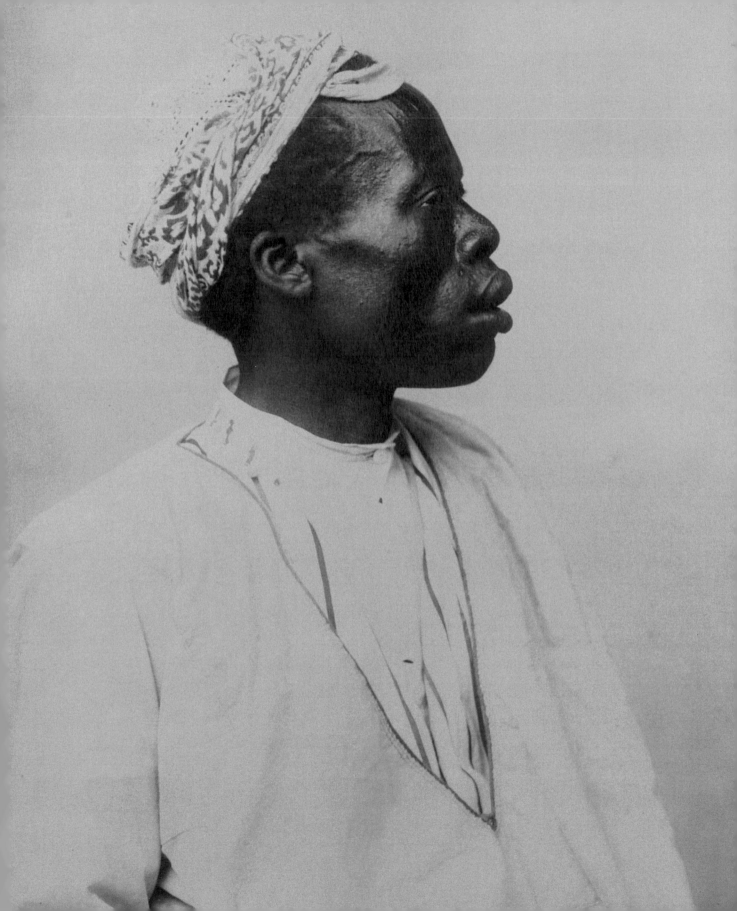

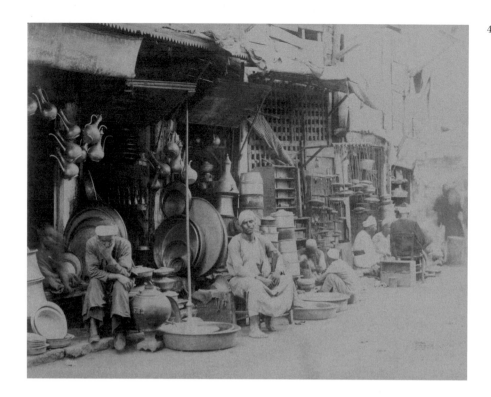

45 *Pot Sellers*
Pascal Sebah
Egypt, ca. 1870
8½ x 10¼ in.
Albumen print from a
collodion glass negative

European tourists commonly purchased souvenir photographs that featured portraits of indigenous North African "types," scenes of "native life," desert views, and market scenes. Tourists also purchased images of themselves and their traveling companions wearing quasi-authentic North African garb, posed against studio backdrops painted with images of palm trees, camels, mosques, or other stereotypical scenes from North Africa. In Egypt, after the opening of the Suez Canal in 1869, the tourist trade and the photographic market increased. Package tours and guide books facilitated European visits to the major monuments of North Africa, and the photography business began to boom. Tourists scaled the pyramids of Egypt with the help of local guides and returned from their journeys with souvenir photographs of their adventures (cat. 46).

While Europeans dominated the photography business in nineteenth-century North Africa, one exception was the Syrian/Armenian photographer Pascal Sebah, who opened a studio in Constantinople in 1857. With his French assistant and partner, Antoine Larouche, Sebah opened another studio in Egypt in 1870. The photographs from Sebah's Egyptian studio are considered some of the best studies of late nineteenth-century Egyptian life (cats. 45, 50, 51, back cover). Sebah passed away in 1886 and his son, Jean, took over the Egyptian firm and began signing the photographs "J.P. Sebah," placing his first initial in front of

46 *Climbing the Grand Pyramids*
Unknown photographer
Egypt, ca. 1880
10½ x 8 in.
Albumen print from a
collodion glass negative

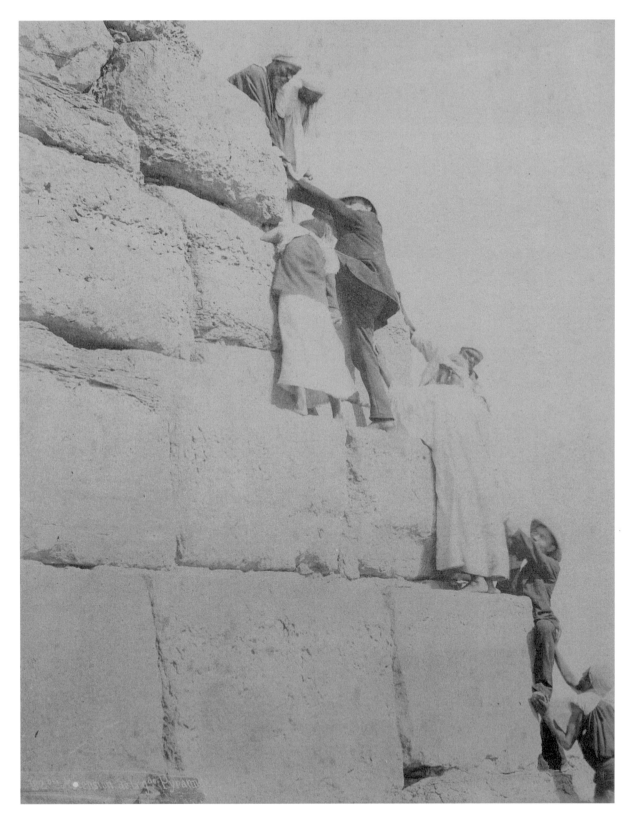

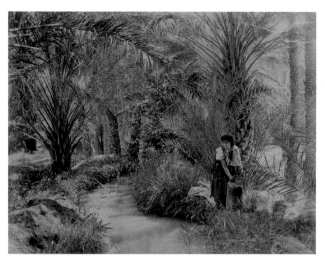

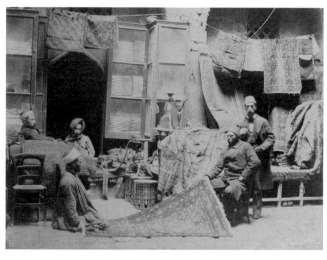

47 *Oasis with Woman Drawing Water*
 Unknown photographer
 North Africa, ca. 1880
 8¼ x 10¾ in.
 Albumen print from a
 collodion glass negative

48 *Rug Sellers*
 Unknown photographer
 North Africa, 1880
 8 x 10½ in.
 Albumen print from a
 collodion glass negative

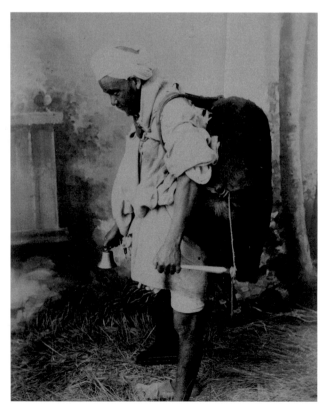

49 *Water Seller*
 A. Cavilla
 Tangier, Morocco, 1880
 9¼ x 7¼ in.
 Albumen print from a
 collodion glass negative

 *A. Cavilla was a Spanish
 photographer who is known to
 have had a studio in Tangier
 in the 1880s.*

50 *Voyeur*
 J. Pascal Sebah
 Egypt, late 19th century
 10¾ x 8¼
 Albumen print from a
 collodion glass negative

 *In 1888, after inheriting his
 father's business, Jean (who signed
 images with the name J. Pascal
 Sebah) went into partnership with
 a French photographer resident
 in Istanbul, Polycarpe Joaillier.
 The firm of Sebah and Joaillier
 became the official photogra-
 pher of the Sultan and worked
 throughout the Ottoman Empire.*

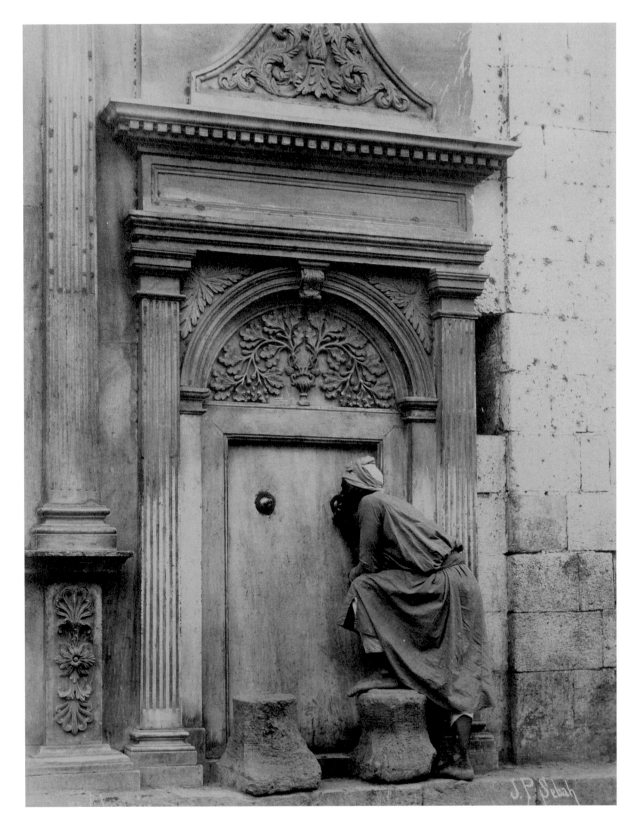

his father's name. For example, the image of an Egyptian Koranic school (cat. 52) signed "J.P. Sebah" may have been taken by either the father or the son, as studio owners commonly reprinted older photos and marketed them as their own. The Sebah studio eventually became Foto Sabah and remained in business until 1952.

While photography flourished in Algeria and Egypt, few studios existed in nineteenth-century Morocco, perhaps because, unlike the rest of North Africa, Morocco was never part of the Ottoman Empire and remained largely closed and hostile to Europeans. Nevertheless, in the 1880s, A. Cavilla, a Spaniard, moved his studio from Gibraltar to Morocco, establishing one of the earliest photographic studios in Tangier. Cavilla often photographed market scenes and architectural views, as well as portraits of individual Moroccan "types" taken against a painted studio backdrop. Cavilla photographed an itinerant water seller carrying a large water-filled animal skin on his back (cat. 49). The man does not gaze at the camera but holds a bell in his hand and looks down in order to give the impression of ethnographic reality. Water sellers commonly roamed Morocco's crowded markets, ringing bells to alert everyone of their presence and selling cups of water for a small fee. However, Cavilla manipulates the scene—the water seller is posed in front of a landscape with trees common to Europe and not to the Mediterranean city of Tangier. Cavilla most likely carried the studio backdrop with him from Europe.

51 *Perfume Merchants*
 J. Pascal Sebah
 Egypt, late 19th century
 10¾ x 8¼ in.
 Albumen print from a
 collodion glass negative

52 *Koranic School*
 J. Pascal Sebah
 Egypt, late 19th century
 8¼ x 10½ in.
 Albumen print from a
 collodion glass negative

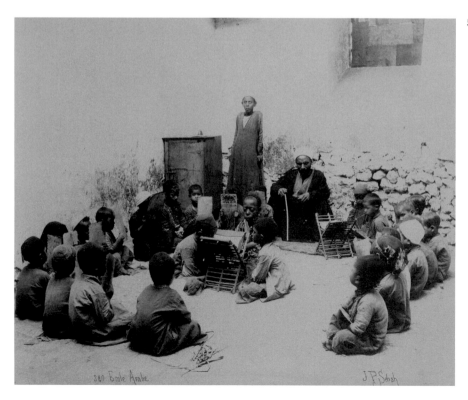

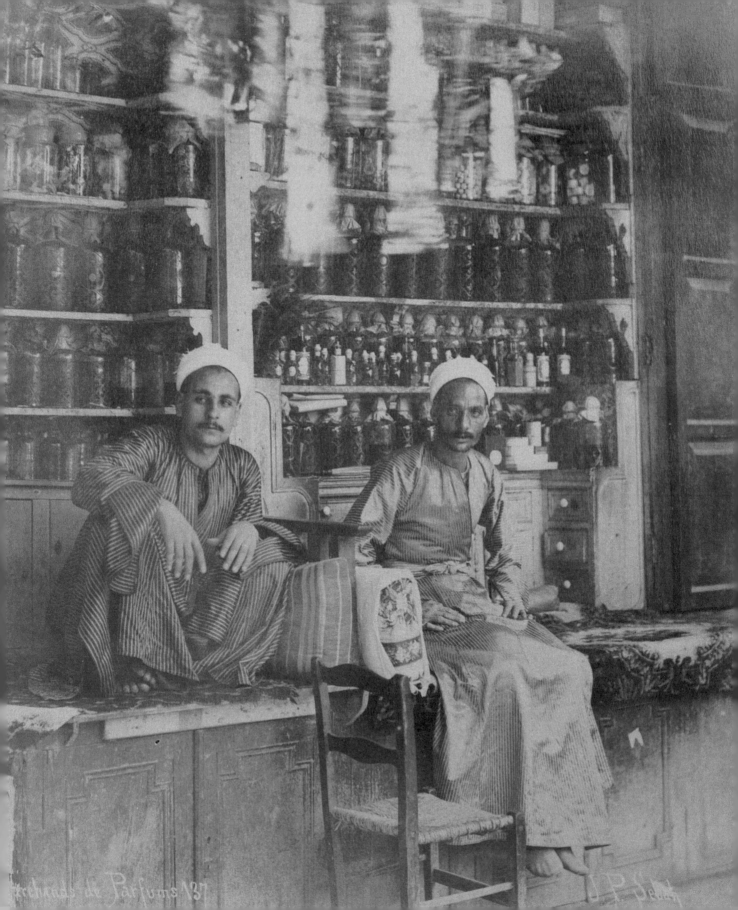

Marchands de Parfums 137

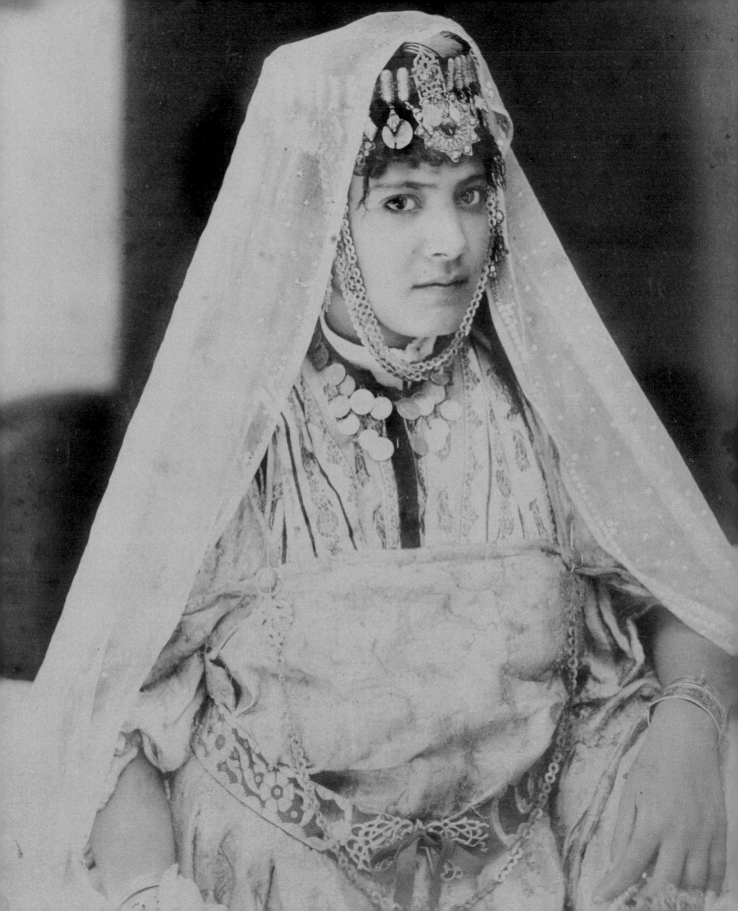

Many European-based photographers chose not to set up studios in North Africa. Instead, photographers like George Washington Wilson (cat. 68), who was based in Scotland, and the Neurdein brothers, Étienne and Louis, who were based in Paris, commissioned photographers to travel widely throughout the region. Their studios purchased formulaic and conventionalized street scenes and portraits of indigenous people, publishing and distributing these tourist photographs under their names. While Wilson's studio closed in 1908, the Neurdein brothers continued to be a major publisher of Algerian and Tunisian tourist photographs from the 1860s until after the First World War when they became known as Lévy et Neurdein Réunis (cat. 53).

George Eastman transformed photography when he invented the Kodak hand camera in 1888, enabling amateurs to take their own photographs. In 1894, the European postal system allowed the use of cards containing written messages on one side and addresses on the other, opening the way to the picture-postcard craze. During this period, photographers made prints from older negatives and printed them as photographic postcards that were circulated throughout the world, resulting in the production of millions of postcards and the demise of the heavy leather-bound photographic travel album. Regardless, many studios stayed in business and began to specialize in developing photographs taken by tourists. They also set up studios near tourist attractions so travelers could purchase a professionally made souvenir photograph taken in front of a major monument, such as the Sphinx or the pyramids at Giza.

North African Photography and Colonial Encounters

Nineteenth-century stereotypes of Africa and Africans reverberate in colonial-era photographs. Scientists used photography to classify humans according to the shape of the skull and their facial features, which were believed to correlate to a person's intellectual capacity. The photograph of a man in profile (cat. 44), labeled in French *Negre Soudan*, was certainly influenced by the pseudo-scientific field of anthropometry, which classified people into racial types, placing Caucasians at the top of the evolutionary scale and Africans at the lowest.[3] The term *Soudan* was commonly used by both North Africans and the French to refer to Sahelian Africa, suggesting that this man had a Sahelian African origin.

The photographs in the Guerrand-Hermès collection present exoticized views of the so-called Orient as imagined by Europeans. Photographers sometimes staged outdoor scenes to suggest that they were portraying a slice of authentic North African life. But, in fact, most photographers catered to European biases and portrayed North Africans as living in a mysterious and

53 *Woman of the Ouled Nails*
Étienne and Louis Neurdein
Algeria, ca. 1880
10½ x 8 in.
Albumen print from a collodion glass negative

Young women from the Berber group Ouled Nails amassed large dowries through their dance performances. Ouled Nails dances are often thought of as the origin of "belly dancing."

In 1863, the Neurdein brothers founded a studio in Paris, Maison Neurdein. Their establishment was known for portraits of famous people, as well as for travel images from France, Belgium, Algeria, and Canada.

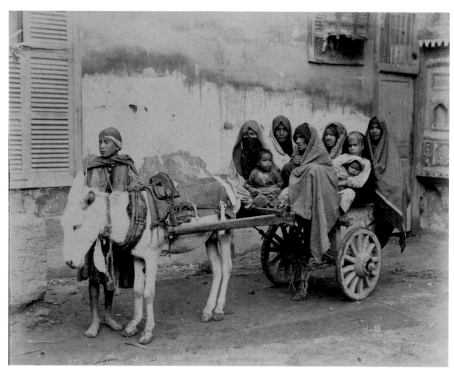

54 *Cairo: Arab Women in Wagon*
Bonfils
Egypt, 1870
8½ x 11 in.
Albumen print from a collodion
glass negative

*Born in France, Felix Bonfils established
a studio in Beirut, Lebanon, in 1867. His
son, Adrien, and wife, Lydie, also became
photographers. The Bonfils family
produced thousands of images and sold
them through their businesses in Beirut,
Cairo, Alexandria, London, Paris, and
Alès, their hometown in France.*

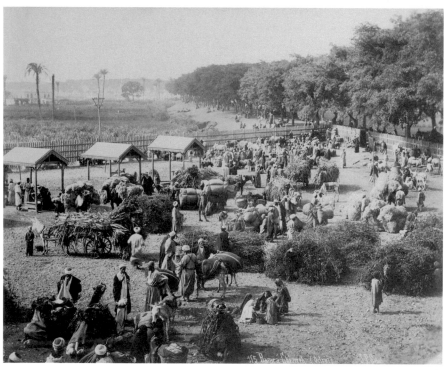

55 *Market at Ghezireh*
J. Pascal Sebah
Ghezireh, Egypt, late 19th century
8¼ x 10⅝ in.
Albumen print from a collodion
glass negative

56 *Group Portrait, Women and Children*
Unknown photographer
North Africa, ca. 1880
10⅛ x 7⅞ in.
Albumen print from a collodion
glass negative

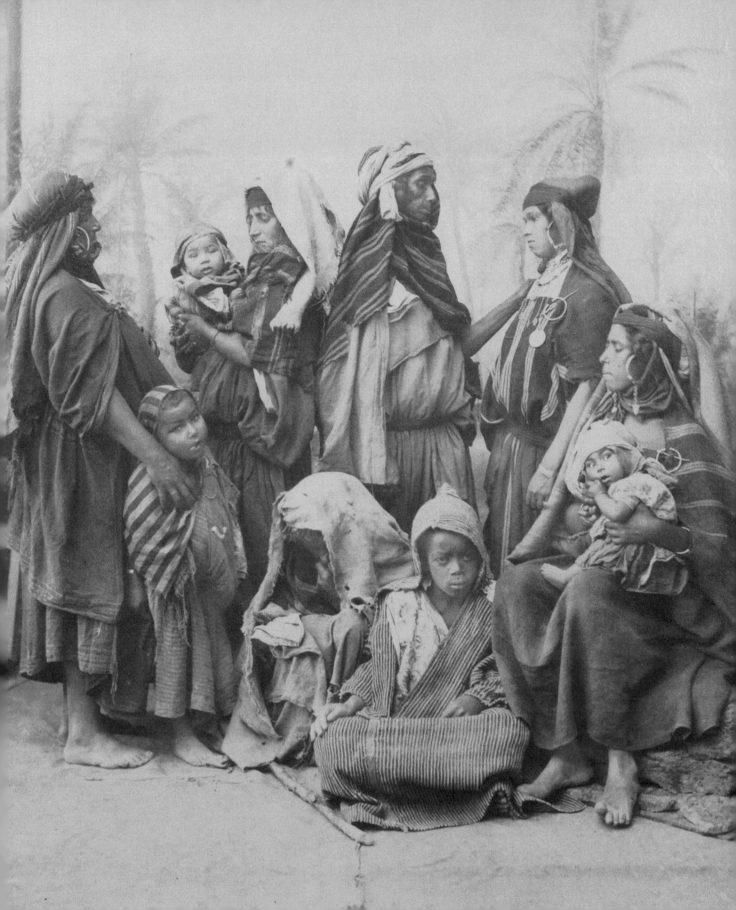

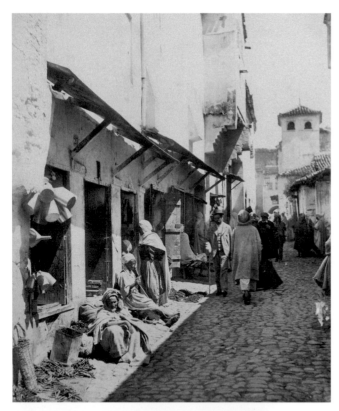

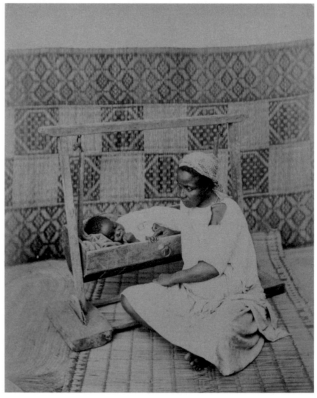

57 Above left:
Mozabite Merchants in Constantine
Étienne and Louis Neurdein
Algeria, 1880
10¾ x 8¼ in.
Albumen print from a
collodion glass negative

58 *Woman and Child*
A. Cavilla
Tangier, Morocco, 1880
9 ¼ x 7 3/8 in.
Albumen print from a
collodion glass negative

59 *Kasbah Gate*
Rodolphe Neuer
Tangier, Morocco, 1910–1920
9¼ x 7 in.
Silver print

*In the early twentieth century,
Rodolphe Neuer published images
depicting ethnic nudes and scenes
from daily life in North Africa.*

60 *Musician*
J. Garrigues
Tunis, Tunisia, 1880
9⅝ x 7¼ in.
Albumen print from a
collodion glass negative

*While many of his images survive,
especially those from Tunisia, little
is known of Garrigues. He appears
to have been active in the 1880s.*

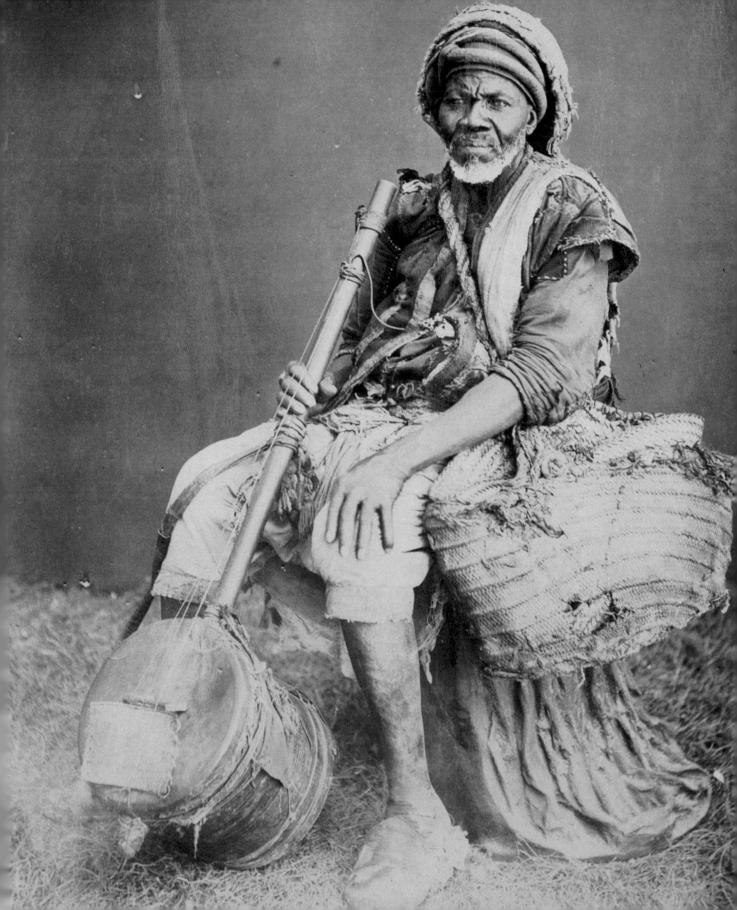

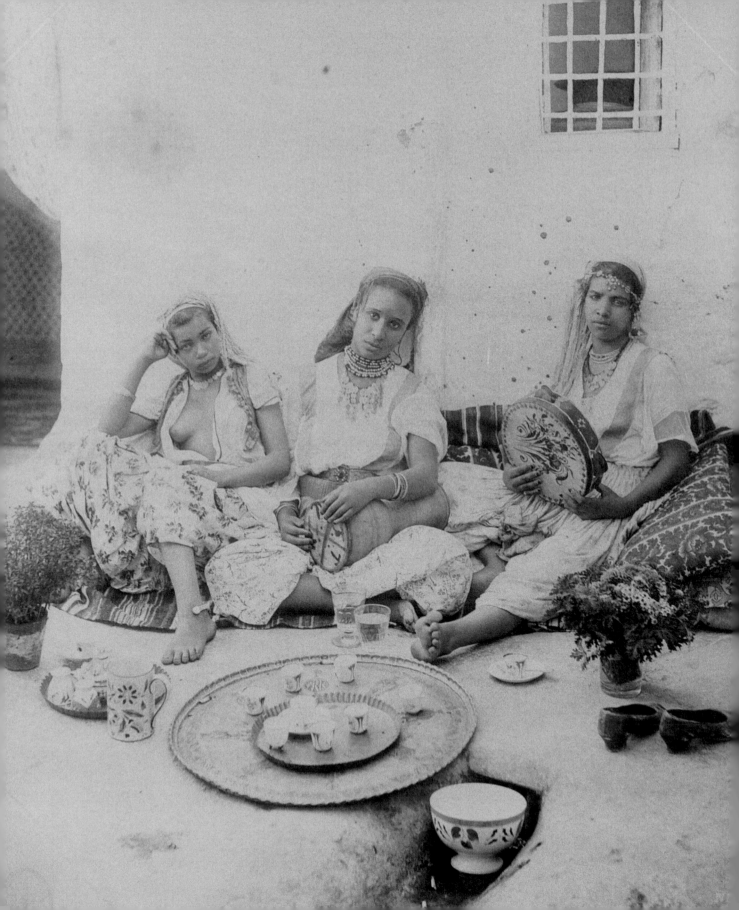

colorfully timeless world that was strikingly different from Europe. A street scene captured in the Algerian city of Constantine includes a European colonial subject wearing a suit in a crowded market (cat. 57). The European stands straight and carries a cane, while the North African men wear turbans and hooded capes. Some lounge in front of shops on the street. For the European viewer, this portrayal of differences in dress contrasted the "exotic" North African with the "civilized" European.

The French public's eagerness to learn about local life in Algeria, a French colony at the time of these images, resulted in a booming market for photographs that appeared to document the benefits of colonial rule. Photographers maintained a supply of props and often paid local models to pose in front of fabricated studio backdrops. One of the most common styles of studio portraits to emerge from colonial Algeria was of partially clothed Algerian women, adorned in elaborate jewelry, reclining or standing in seductive and sensual positions, as seen in the Neurdein brothers' image of three women resting on rugs and pillows (cat. 61). The window's bars suggest that these women are imprisoned inside a harem. Two of the women play musical instruments while the third woman, who appears listless and bored, lounges with an open shirt, revealing one of her breasts. In *The Colonial Harem*, Malek Alloula writes that European photographers staged their erotic photographs and used props to give the pretense of ethnographic reality and to suggest that they gained entry into the harem. Alloula interprets these images as representing French fantasies regarding the "lascivious" North African woman and her inaccessibility behind the forbidden harem walls.

The relationship between nineteenth-century European Orientalist photography and painting further explains the misrepresentation in some colonial-era photographs. European photographers often marketed and sold their work to painters, consciously dressing their subjects in elaborate garb and replicating themes that became common in Orientalist paintings, such as people playing chess, smoking water pipes, drinking tea, and reclining on cushions while partially dressed. Painters, including Jean-Léon Gérôme and John Frederick Lewis, used photographs as study aids to accurately reproduce details of dress, architectural decoration, and various accoutrements in their extraordinarily lavish paintings.

Photography and North African Social History

While nineteenth-century photographs certainly exhibit elitist European attitudes toward North Africa and the Muslim world, these photographs also provide a valuable glimpse into nineteenth-century North African life. Some photographers attempted to present a more truthful view of North Africa to the European public.

61 *Three Seated Women*
Étienne and Louis Neurdein
Algeria, ca. 1880
10½ x 8¼ in.
Albumen print from a
collodion glass negative

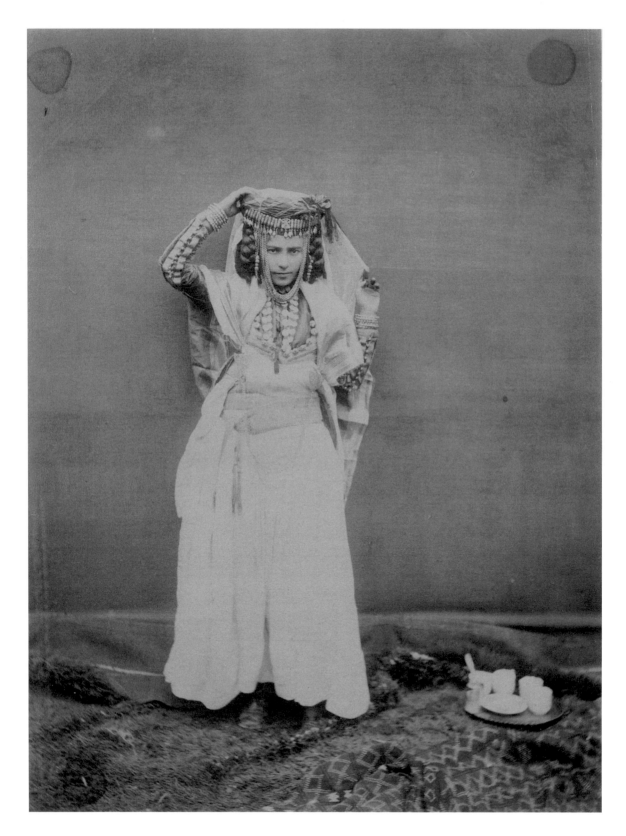

Their photographs of market stalls, local crafts, and street characters portray the vibrancy of street life, for example, capturing what appears to be a parking stall for donkeys at an Egyptian market (cat. 55).

Upon closer examination, even some staged studio portraits describe historical events and express African experiences. In her analysis of colonial-era postcards from Africa, Christraud Geary encourages scholars to consider African photographic subjects as active agents who asserted views of themselves and represented their personal, social, and religious identities through particular props, clothing, and poses, even if the photographer was European. According to Geary, the sitter's intention and his or her interaction with the photographer give the subject agency and an identity.[4]

While photographers of this period likely viewed their subjects as representative of exotic indigenous "types," upon closer examination, photographs often captured specific moments in African history that have been forgotten. In one example, a dark-complexioned Tunisian man is posed with a type of plucked lute called a *gombri* (cat. 60), which is played in Tunisia by the descendents of enslaved Sahelian Africans during possession-trance ceremonies. For centuries, trans-Saharan caravans transported men and women from Sahelian Africa to be sold in North African slave markets. After the colonial occupation of North Africa, slavery was banned and the descendents of enslaved peoples formed communities for themselves known as Gnawa in Morocco, Diwan in Algeria, and Stambali in Tunisia. These groups cure illnesses through a type of spirit possession/trance that derives from both North African Sufism and Sahelian African spirit possession, such as Hausa *bori*. They evoke spirit possession through specific forms of dress, color symbolism, dance, incense, and rhythms played on musical instruments derived from Sahelian Africa, including the *gombri*. The man photographed with the *gombri* was undoubtedly a member of a Tunisian Stambali group and poses holding the instrument he played during these ceremonies. The presence of a large woven sack draped over the subject's shoulder suggests that in addition to possession/trance ceremonies, he may have performed as an itinerant musician.

A similar image of a Sahelian African man was taken by A. Cavilla in Tangier. Cavilla photographed a dark-complexioned Moroccan man in profile wearing a headdress with a conical projection and long tresses adorned with shells and beads (cat. 67). In contemporary Morocco, Gnawa continue to wear similar headdresses during ceremonial occasions, revealing the antiquity of this headdress and its possible connection to Sahelian Africa examples. Some photographs, therefore, illustrate details of the history of the trans-Saharan relationship, including the slave trade. A careful reading of these photographs shows the rich

62 *Woman of the Ouled Nails in Festive Dress*
Unknown photographer
Bou Daada, Algeria, ca. 1870
10¾ x 8 in.
Albumen print from a collodion glass negative

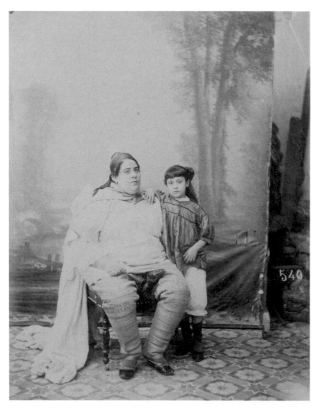

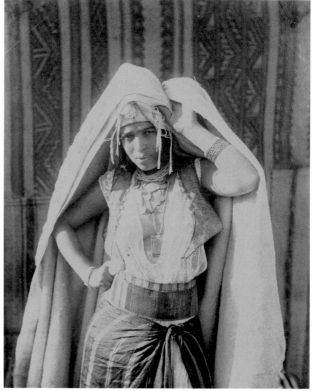

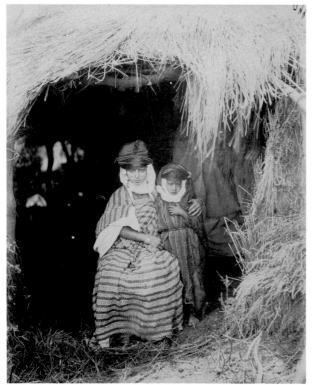

63 Above left:
Jewish Mother and Daughter
J. Garrigues
Tunis, Tunisia, ca. 1880
10¼ x 8 in.
Albumen print from a
collodion glass negative

64 *Young Girl with Jewels*
Attributed to Étienne
and Louis Neurdein
Algeria, ca. 1870–1880
10¾ x 8¼ in.
Albumen print from a
collodion glass negative

65 *Woman before Straw Hut*
J. Garrigues
Tunisia, ca. 1880
10⅛ x 7⅞ in.
Albumen print from a
collodion glass negative

66 *Young Girl*
Unknown photographer
North Africa, ca. 1870
10¼ x 7½ in.
Albumen print from a
collodion glass negative

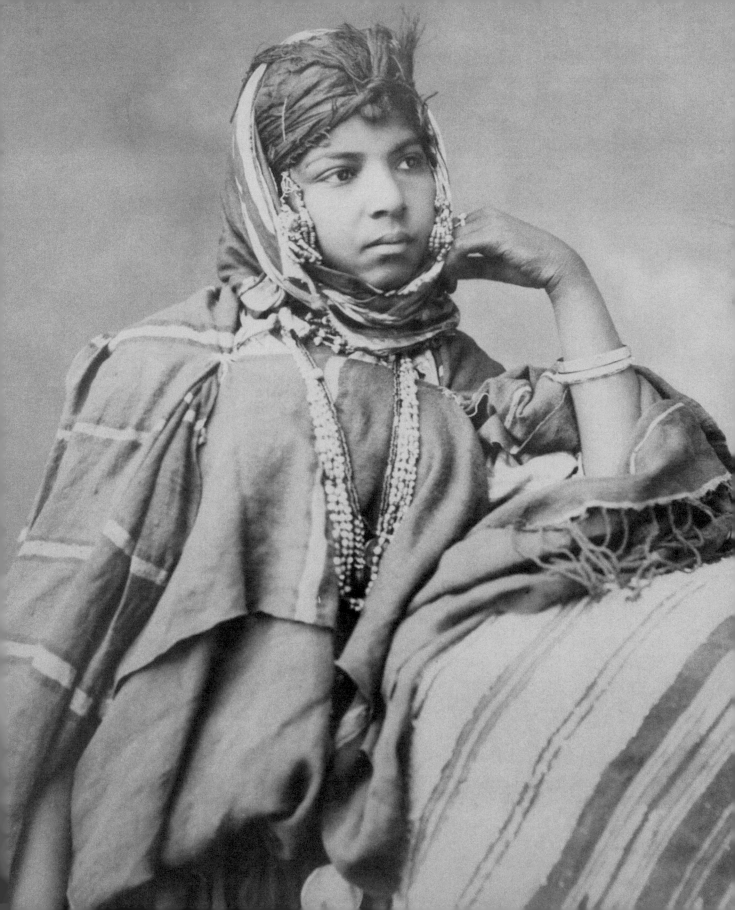

cross-fertilization of religions and philosophies that occurred between North and sub-Saharan Africa.

Nineteenth-century photographs may also provide information about historic forms of dress that no longer exist in contemporary North Africa. Until the mid-twentieth century, the majority of North African women wore draped garments called *izour* or *lizour* (singular *izar* or *lizar*). Scholars often compare this form of daily attire to ancient Greek or Roman dress. The *izar* was made from a piece of handwoven wool fabric measuring three meters by one and one-half meters. Men and boys typically wore hooded capes and gowns that women wove from black, brown, or beige wool to create a solid colored or striped garment (cat. 56).

As early as the nineteenth century, however, imported cotton and other fabrics replaced the traditional wool cloth, and North African women preferred to wear *izour* over tailor-made and imported dresses (cat. 53). Handwoven cloth became associated with a lack of prosperity, even though in rural areas many North Africans continued to wear these fabrics until the early twentieth century. The scene, by an unknown photographer, emphasizes the poverty of the subjects by crowding a group of barefooted women and children dressed in handwoven cloth into a studio (cat. 56). All but two children look grimly away from the camera, emphasizing the somberness of the image.

Some photographs show the various styles of jewelry created and worn in nineteenth-century North Africa. When a woman wrapped an *izar* around her body, she held it together at her shoulders with two silver pins, or fibulae, and a belt around her waist. The most basic style of fibula consisted of a pin with a ring (cat. 56), but often jewelers would add triangular filigree pendants linked to a long silver chain. North African women also adorned themselves with necklaces made of silver or gold coins and arranged their hair into voluminous styles, wrapped with various types of scarves, fabric cords, and silver and bead pendants (cats. 53, 64, 66).

Some of the most iconic images from North Africa in the nineteenth century feature Ouled Nail women (cats. 53, 62). Under French rule, the term *Ouled Nail* was used to describe poverty-stricken girls from the southern Algerian desert who worked for the French as dancers, entertainers, and prostitutes in order to accumulate large dowries and increase their marriageability. French photographers in Algeria fetishized Ouled Nail women, commonly picturing them in arranged compositions: dancing with veils, smoking cigarettes or water pipes, playing cards, drinking tea, and standing in suggestive poses. Ouled Nail women became known for the erotic belly dances they performed at the universal expositions in Paris in the late nineteenth and twentieth centuries.[5]

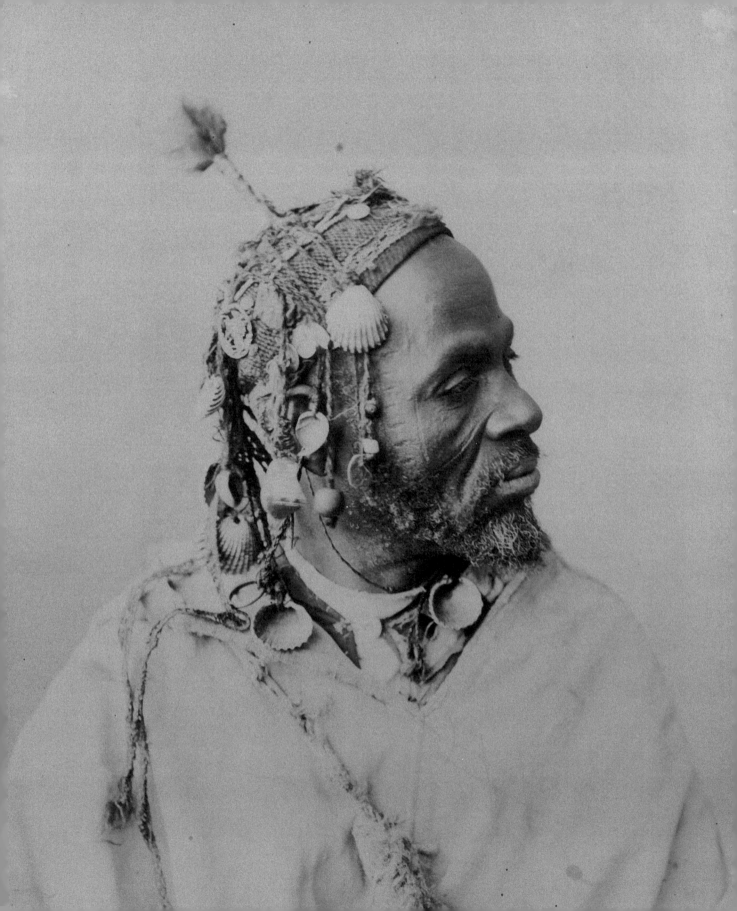

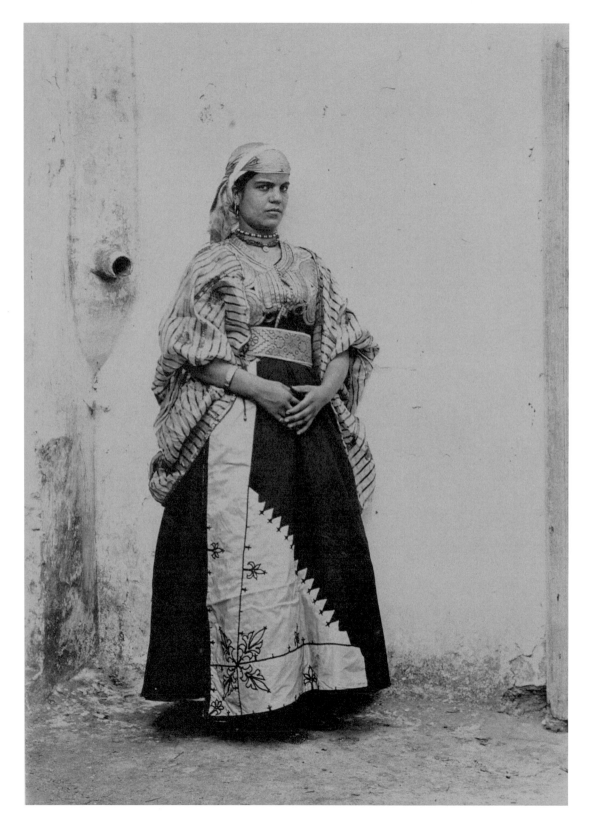

The dress of Jewish women in North Africa was also a subject of interest to nineteenth-century European photographers. George Washington Wilson's studio for example, published the photograph of a Moroccan Jewish woman (cat. 68) who came from the ancient Jewish population living in Morocco. Jews, along with sub-Saharan Africans and the women of the Ouled Nails, were some of the exotic characters that populated the imagery of North Africa in this period.

In the nineteenth century, Jewish brides wore velvet ceremonial dresses called *keswa el-kbira*, meaning "great costume." Originating in Spain, Jews transported this garment when they settled in northern Moroccan cities in the fifteenth century. Given to a bride by her father, the outfit consisted of a floor-length wraparound skirt with gold embroidery, a lavishly decorated jacket, detachable long sleeves, and a wide belt. The *keswa el-kbira* captured the imagination of European painters, including Eugène Delacroix and Alfred Dehodencq, who painted Jewish women in this type of outfit. Until the mid-twentieth century, Jewish women continued to wear *keswa el-kbira* for their marriages and for various ceremonial occasions.[6]

European photographs played a significant role in determining perceptions of colonial North Africa. The photographs in the Xavier Guerrand-Hermès collection delineate some of the many encounters that occurred when various cultures met and grappled with each other across ethnic, religious, and other boundaries in the late nineteenth century.[7] While much has changed, the diversity and cosmopolitanism seen in these images from a century ago continue to be part of the fabric of life in Morocco, Algeria, Tunisia, and Egypt today.

68 *Jew of Tangier*
George Washington Wilson
Morocco, ca. 1875
8½ x 6 in.
Albumen print from a
collodion glass negative

A pioneering Scottish photographer, George Washington Wilson (1823–1893) traveled throughout Scotland, as well as Gibraltar, Morocco, South Africa, and Australia. He developed a successful business as a photographic publisher distributing cartes de visite, postcards, and stereographs for the tourist industry.

NOTES

1 Because of the negative connotations of the word Berber (from the Latin *barbarus* or barbarian) Berbers call themselves *Imazighen*. *Amazigh* is the singular and adjectival form. The *Imazighen* consider themselves the indigenous inhabitants of North Africa, and refer to themselves by their group names.

2 The source for much of the information on photography in North Africa discussed in this essay is Ken Jacobson's excellent book, *Odalisques and Arabesques: Orientalist Photography 1839–1925* (London: Bernard Quaritch Ltd., 2007).

3 Geary, Christraud M., *In and Out of Focus: Images from Central Africa, 1885–1960* (Washington D.C.: Smithsonian National Museum of African Art, 2002), 17.

4 Ibid., 20.

5 Zeynep Çelik and Leila Kinney, "Ethnography and Exhibitionism at the Expositions Universelles," *Assemblage*, No. 13 (Dec. 1990), 40.

6 See Jean Besancenot, *Costumes of Morocco* (London: Kegan Paul International Limited, 1990), 176; Vivian B. Mann, ed., *Morocco: Jews and Art in a Muslim Land.* (New York: Merrell in association with The Jewish Museum, 2000), 176; and Yedida Kalfon Stillman, *Arab Dress from the Dawn of Islam to Modern Times: A Short History*, ed. Norman A. Stillman (Leiden: Brill, 2000), 99.

7 Mary Louise Pratt, *Imperial Eyes: Travel Writing and Transculturation* (New York: Routledge, 1992), 4.

SELECTED BIBLIOGRAPHY

Alloula, Malek. *The Colonial Harem.* Manchester: Manchester University Press, 1987.

Besancenot, Jean. *Costumes of Morocco.* London: Kegan Paul International Limited, 1990.

Çelik, Zeynep, and Leila Kinney. "Ethnography and Exhibitionism at the Expositions Universelles." *Assemblage*, No. 13 (Dec. 1990), 34–59.

Geary, Christraud M. *In and Out of Focus: Images from Central Africa, 1885–1960.* Washington D.C.: Smithsonian National Museum of African Art, 2002.

Jacobson, Ken. *Odalisques and Arabesques: Orientalist Photography 1839–1925.* London: Bernard Quaritch Ltd., 2007.

Mann, Vivian B., ed. *Morocco: Jews and Art in a Muslim Land.* New York: Merrell in association with The Jewish Museum, 2000.

Pratt, Mary Louise. *Imperial Eyes: Travel Writing and Transculturation.* New York: Routledge, 1992.

Spring, Christopher, and Julie Hudson. *North African Textiles.* London: British Museum Press, 1995.

Stillman, Yedida Kalfon. *Arab Dress from the Dawn of Islam to Modern Times: A Short History*, ed. Norman A. Stillman. Leiden: Brill, 2000.

CONTRIBUTORS

Cynthia Becker is an assistant professor at Boston University and a scholar of African arts, specializing in the arts of the Imazighen in northwestern Africa. Professor Becker has served as a consultant for numerous museum exhibitions and published articles on the visual and performing arts of the Imazighen, as well as the trans-Saharan slave trade. She is the author of *Amazigh Arts in Morocco: Women Shaping Berber Identity*.

Kristyne Loughran is an independent scholar in Florence, Italy, specializing in the arts of the Tuareg. She has published and presented extensively on the subject of Tuareg jewelry and fashion and is the co-editor of *Art of Being Tuareg: Sahara Nomads in a Modern World* (with Thomas K. Seligman) and author of *Art from the Forge*.

COLLECTION NOTES

The following objects, part of a generous gift from Xavier Guerrand-Hermès, are in the collection of the Museum for African Art: cats. 3, 4, 11, 13, 15, 17, 18, 23, 24, 29, 33, 34, 41, 43. All other objects in the catalogue are in the Xavier Guerrand-Hermès collection.